The Illuminated Life of

Maud Le

The Illuminated Life of
Maud Lewis

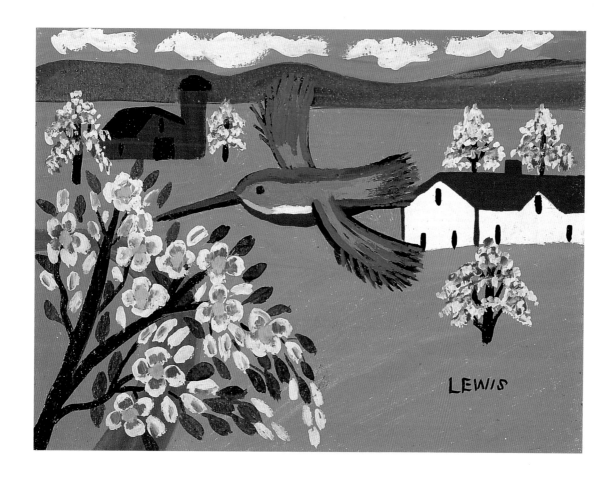

Text: Lance Woolaver Photographs: Bob Brooks

Nimbus Publishing Limited/Art Gallery of Nova Scotia

Copyright © Lance Woolaver, Bob Brooks

Nimbus Publishing Limited
PO Box 9301, Stn A
Halifax, NS B3K 5N5

Art Gallery of Nova Scotia
PO Box 2262
1741 Hollis St. at Cheapside
Halifax, NS B3J 3C8

All photographs courtesy Bob Brooks unless otherwise noted.
Photography by Bob Brooks uses all Kodak film, Nikon
and Hassalblad camera and lenses.
The photographer acknowledges the support of
Jerry and Johanna Griffin; Mrs. Avora Morton;
Doug Ives and Shirley Robb, NS Visual Communications;
Kevin McGrath, Geri Nolan Hilfiker, AGNS; David Middleton and staff,
Carsand Mosher Professional Imaging Centre, Halifax.

Design: Semaphor Design Company, Halifax

Canadian Cataloguing in Publication Data
Woolaver, Lance, 1948–
The illuminated life of Maud Lewis
Co-published by the Art Gallery of Nova Scotia.
ISBN 1-55109-176-3 (bound)
ISBN 1-55109-217-4 (pbk.)
1. Lewis, Maud, 1903–1970. 2. Painters—Nova Scotia—Biography.
I. Brooks, Bob. II. Art Gallery of Nova Scotia. III. Title.
ND249.L447W66 1996 759.11 C96-950138-2

Title page: Untitled, Circa 1963, Oil on particleboard, 23 x 30.25 cm, Collection of Mrs. Lucy Kerr

Contents

Acknowledgements

Writing this book with Bob Brooks' photographs at hand was inspirational and instructive: when in doubt about the visual details of Maud, her husband Everett, and their little house, I had only to examine them to verify my childhood recollections.

I will always be in debt to the constancy of Dorothy Blythe and the care of Elizabeth Eve in the development and editing of this book. When we are old and grey, I think we will look back and be happy we did not abandon its difficult course.

So many Maud Lewis fans wrote letters and offered anecdotes it would be impossible to thank them all here. From Digby County to Washington, D.C., the stories came fast and furious, each day's mail bringing a little gem, often humorous, sometimes heartbreaking. There are those however, whose unique contributions demand mention: without the kindnesses of Fred Trask, Stephen Outhouse, Nellie Muron, Murray Barnard, Arthur Sullivan, Carvell Gray, Doris McCoy, Gordon Mount, Bill Ferguson, Gertrude Hersey, John Kinnear, Muriel Veinot, Bert Potter, John Carrol Whitaker, Free Sibley, and Shirley and Phillip Woolaver this book would have been a dry recitation indeed. In most cases these kind contributors provided answers to mysteries, some sent unrequested memorabilia and artworks. It is a great testimonial to Maud Lewis that even now so many would volunteer their possessions and be compelled to recount their stories.

Finally I would like to thank Bernie Riordon, Judy Dietz, and Kelly Regan with the Art Gallery of Nova Scotia, and Steven Slipp at Semaphor Design. When I began this book, these, with Nimbus Publishing, were the partners I wanted. *Per ardua ad astra*, as my Dad's wings once read.

L. G. W.

Halifax, 1996

For their contributions to this book and to the national exhibition of Maud Lewis' art, the Art Gallery of Nova Scotia wishes to acknowledge, with gratitude, the following:

Lance Woolaver, author; Bob Brooks, photographer; Dorothy Blythe, Nimbus Publishing; Peter Godsoe, Jack Keith, Sandra Stewart, Scotiabank; Jack and Joan Craig, Craig Foundation for the Visual and Performing Arts; Janet Conover and Nina Wright, Arts and Communications Counsellors; Steven Slipp and Neil Meister, Semaphor Design; Kelly Regan, researcher; Maud Lewis Painted House Society; AGNS Maud Lewis House Committee: Merv Russell, chair; Alan Abraham, Ken Connell, Maxine Connell, Ann Marie Coolen, Fred MacGillivray, Andy Lynch, Stephen Outhouse, Bob Brooks; Province of Nova Scotia: Premier John Savage, Hon. John McEachern, Hon. Robert Harrison, Hon. Richard Mann; Hon. Sheila Copps, Museums Assistance Program, Dept. of Canadian Heritage; James Spatz, Southwest Properties Ltd.; AGNS section heads and their staff: Virginia Stephen, Deputy Director & Head of Programming; Judy Dietz, Manager of Collections & Gallery Services; Miriam Garrett, Manager of Development & Public Relations; Sue Tingley, Administrative Officer; Sandra Winter, Manager, Gallery Shop; Laurie Hamilton, Fine Art Conservator; Susan Foshay, Exhibitions Curator; Brenda Garagan, Christine Dawe, Robert Scott; Craig Dix and Jennifer McLaughlin, Conservators; Allison Bishop, Dept. of Education & Culture; Robert Blumsum, Dept. of Natural Resources; Heather Harris; Tony Gillis, Brian Mackay-Lyons, Gillis Mackay-Lyons Architects.

We are most grateful to the lenders to the exhibition and to individuals who have generously donated paintings and contributed funds to the Gallery for this exciting project.

Sponsor's Message

When Maud Lewis sat in her tiny Digby, Nova Scotia house, in front of an empty canvas, little did she know that her work would touch the hearts of thousands of people across Canada and around the world. For, in Maud's art, there is a silent yet colourful celebration of the simple, magical life that many yearn for today. And the fact that she painted so warmly while suffering the debilitating effects of illness and deformity is a true inspiration to everyone.

Nova Scotians have known the innocent beauty of Maud Lewis' work for many years, and her paintings hang in galleries and collections in Europe and across North America. Until now, however, many Canadians have not had the opportunity to see her work first hand. Scotiabank is proud to work with the Art Gallery of Nova Scotia to bring these wonderful works of art to galleries and museums across Canada, and we expect that the national exhibition in 1997–98, together with this illustrated biography, will be heart-warming experiences for people of all ages.

Peter C. Godsoe,
Chairman and Chief Executive Officer, Scotiabank

Introduction
Maud Lewis 1903—1970

*O*n most fine days the charmingly decorated door to Maud Lewis' house was open, inviting travellers along the road who read her sign, "Paintings for Sale", to stop. Over the years many visitors accepted her invitation, whether by chance or by design, and in exchange for a few dollars became owners of her delightful works of art—a pair of cats, an ox, or a pony and sleigh, whatever Maud had for sale at the time.

In 1996, almost thirty years after Maud's death, the Art Gallery of Nova Scotia sent an invitation to anyone who owned Maud Lewis paintings to come and assist in developing the definitive inventory of works on which to base the exhibition and this book. In the spirit of Maud's own open door, those who were once her customers and patrons came and made it possible for the public to connect once again with the work of one of Canada's best loved folk artists.

Born in 1903 in South Ohio, Nova Scotia, Maud Lewis spent her entire life within one-hour's drive of her birthplace. By many standards she led a confined life, rarely going far from her own home, but the vitality and joy in her inner life were reflected in the resplendent colour and composition of her paintings. In her early thirties, when she married Everett Lewis, a fish peddler, she moved from Digby to the little house in Marshalltown, a house that she painted throughout with cheerful and delightful images. No area was excluded: the windows, the stairs to the loft, and even the stove were a celebration of her unique artistic expression.

Following the deaths of Maud and Everett, this house unfortunately fell into disrepair and quickly deteriorated. In 1979 the Art Gallery of Nova Scotia became involved in its preservation. Arrangements were made to have the Canadian Conservation Institute carry out an analysis of the building. The Maud(e) Lewis Painted House Society, a group of local citizens interested in keeping alive the memory of their beloved folk artist, worked diligently to get support to carry out their objectives of having the house restored and open to visitors.

By 1983 it was evident that there was not sufficient financial support in the community to bring the project to fulfilment, and the house, its contents and the property were offered to the Art Gallery. All options were explored, the first concern being that a cultural object should, if at all possible, be installed *in situ*.

Facing page: Maud's portraits of oxen became her most requested work.

Oxen in Spring
Oil on board
30.5 x 35.6 cm
Collection of Les and Clare Hine

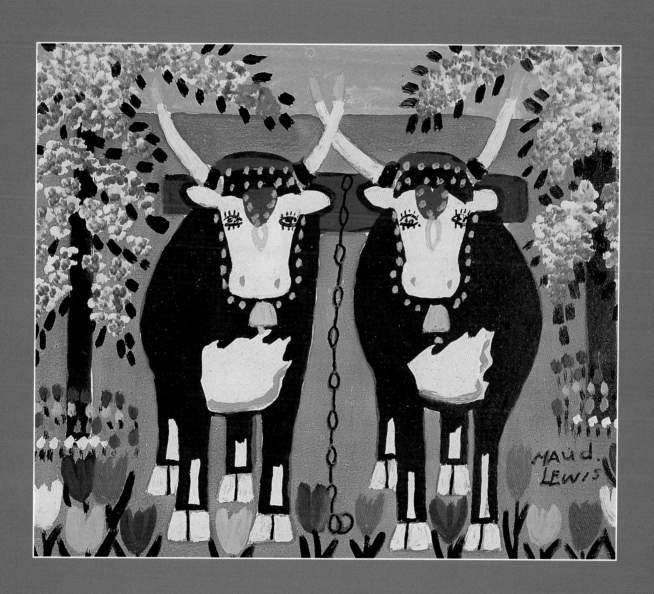

Portrait of Eddie Barnes and Ed Murphy, lobster fishermen, Bay View, N.S.

Untitled, 1965
Oil on masonite
32.3 x 35 cm
Collection of Helen Beveridge

When this did not seem possible to achieve, it was decided to move the whole structure into storage. The Nova Scotia Department of Supply and Services subsequently lifted it from the Marshalltown site and placed it in a hangar in Waverley, near Halifax, Nova Scotia.

The house was now in safe-keeping until it could be installed as an integral component of the gallery's permanent collection. At this time a site on the Halifax waterfront was under consideration for a new Art Gallery of Nova Scotia in which its internationally recognized folk art collection would be prominently displayed. Along with Maud Lewis' painted artifacts, the house was to be a focal point in this growing collection.

The gallery's association with folk art began in 1976 with an exhibition of twentieth-century Nova Scotia works. This inaugural event was an instant success and resulted in a strong commitment to this area of interest. "Folk Art of Nova Scotia" not only displayed local artists in a national arena, it also acknowledged that the work of self-taught artists is a legitimate form, worthy of recognition by institutions and the general public. Folk art exhibitions of local, national and international significance soon followed. The gallery was responsible for assembling "Gameboards" (1981), "Francis Silver 1841-1920" (1982), "A Record for Time" (1985), "Interior Decorative Painting in Nova Scotia" (1986), "Spirit of Nova Scotia: Traditional Decorative Folk Art 1780-1930" (1987), "Nova Scotia Folk Art, Canada's Cultural Heritage" (1990), and "Nova Scotia Folk Art" (1992). Venues for some of these exhibitions included the National Gallery of Canada in Ottawa, the Art Gallery of Ontario in Toronto, Canada House in London, England, and the Canadian Embassy in Washington, DC, with the result that Nova Scotia's special legacy of folk art developed an international reputation for the province, the gallery and, of course, the individual artists.

Up to now the artists had been less prominent than their works, known generally as folk art. The creation of these objects grew out of the utilitarian needs

and the individual situations in which settlers found themselves at any particular time in Nova Scotia. In the eighteenth and nineteenth centuries the powerful cultural influences of Britain and America hindered the development of a home-grown culture that would reflect the various backgrounds of the populace. By the 1880s, with Nova Scotia in good economic health as a result of its resource-based industries, prosperity brought leisure, which in turn produced cultural expression. Throughout the province there were painters, sculptors, textile artists and others who created items with character and charm. There was, however, no formality or cohesion in this production. The artists were working for the most part in isolation from each

Oakdene School, Bear River, Annapolis County, N.S.

The Schoolyard, undated
Oil on board
22.8 x 30.5 cm
Collection of the Woolaver family

other and from mainstream art and their work was not given any significant consideration until the latter half of the twentieth century when serious collections, public and private, and the increased interest by dealers, curators, and scholars brought to light artists like James Hertle, Francis Silver, Collins Eisenhauer, Joe Norris, Ellen Gould Sullivan and Maud Lewis. Only with this "mainstream" interest in folk art were these artists seen as having contributed significantly to the cultural development of the province.

Folk art glories in self-expression and the artist is generally considered to be self-taught. The artwork of Maud Lewis epitomises the best of this tradition by illustrating an art form that has emerged from the heart and soul of Canada, free from the trappings of "high art." It is a spontaneous and tangible extension of the life and experiences of its creator. This is the art of the ordinary person and it reflects a re-visiting of values, a re-examination of the essence of life and a purity of purpose and vision that provides one of the most exciting avenues of visual expression in the world today.

"People's art," as it was termed by Canadian art historian J. Russell Harper, now receives respect and serious attention. In 1973 Harper noted "there is no easy

The charmingly decorated door to Maud Lewis' house.

definition of folk art ... a folk object is one overlaid with the decorative or artistic touches of a sensitive craftsman and intended for the humbler homes, settings where it will be enjoyed for its own sake." Other scholars place the emphasis differently. A standard American text describes folk art as "a traditional, often ethnic expression which is not affected by the stylistic trends of academic art." Many North American writers prefer to speak of "naive art" or "primitive art" to avoid the connection of the term "folk" to a particular ethnic group. European writers often choose the term "popular art" to suggest its origins among ordinary people.

One concern with all these definitions is that they address only the product of folk expression. They are devised to accompany objects in museum displays. Any serious definition must also consider the process of folk art's intention and must give credit to the creative expression of artists who draw on a community of general knowledge about their own past and present in order to produce works of the imagination divorced from the parameters of the professional art community. While this process may manifest itself in a range of expression, from raw primitive to charming naiveté, folk art presents an aspect of material culture through which one can observe the social history of a community, such as rural Nova Scotia. The desire to identify with a special cultural value is evident in Maud Lewis' work by the recurrence of motifs that are determined by a rural life. Flowers, cats, sleigh rides, birds, deer, and teams of oxen are images drawn directly from the conditions and the experiences of the artist's own life. Maud's inner strength, courage, determination, humour, and optimism illuminated this world so that she transformed something seemingly mundane into brightness and vitality.

This tribute to Maud Lewis chronicles her life and work. It is the result of a collaboration between Nimbus Publishing and the Art Gallery of Nova Scotia that was born out of the latter's plans to circulate an exhibition of Maud Lewis' works nationally. Author Lance Woolaver has spent years compiling the Maud Lewis story, and his family's long-standing association with the artist makes him the ideal author. His knowledge and love of the subject are evident in this work, as they were in two earlier books which featured Maud's paintings and in his recently produced and published play entitled "World Without Shadows" (Stage Hand Publishers 1996). Photographer Bob Brooks has brought his personal style and technical skill to bear in the reproduction of images of Maud and her work. We are indebted to both Lance and Bob for keeping the memory of Maud Lewis alive and for allowing future generations to enjoy the Maud Lewis story and her art.

Furthermore, researcher Kelly Regan has carefully compiled an inventory of works and stories from those customers and patrons who brought their Maud Lewises to the gallery. The response was overwhelming and the great admiration, respect, and love for Maud, as well as the pride in owning her artwork was evident in everyone with whom she spoke and corresponded.

Many things have happened since the Art Gallery's initial involvement in the preservation of Maud Lewis' legacy, in 1979. Firstly, when the proposed waterfront site did not come to fruition, plans for the conservation and display of the Maud Lewis house had to be put on hold. It was not until five years after the finalization of the Gallery's first permanent home, at 1741 Hollis Street in Halifax, that the original objectives were revived. A special committee, chaired by Merv Russell, was formed to raise the funds for the conservation of the house and to secure a permanent location. In addition, the gallery adopted a five-year strategic plan that identified a proposed expansion with a gallery dedicated to Maud Lewis, including, of course, the house. With an action plan in place, a campaign strategy was developed and then with the generous support of the Department of Canadian Heritage and the kind assistance of Sunnyside Mall in Bedford, Nova Scotia, a site was provided in which the conservation treatment of the house could be undertaken.

Concurrent with the efforts to prepare the house for permanent exhibit, a plan to develop the Marshalltown site as a memorial was begun in 1996. With the generous contribution from the community, people throughout Nova Scotia, this was realized by the fall of 1996. The Digby Board of Trade and local community efforts headed by Ken and Maxine Connell and assisted by Stephen Outhouse ensured that this was accomplished on time, with care and attention.

As for the exhibition itself, the plans really began to take shape in 1995 when Scotiabank announced that it would be the presenting sponsor, and then in 1996, when the work was under way, the Craig Foundation for the Visual and Performing Arts confirmed its associate sponsorship. After opening in Halifax in January 1997, the exhibition will proceed on a national tour over the next two years.

The various components of the Maud Lewis Project present the gallery with some excellent opportunities to carry out its mission to "bring art and people together" and to reach out to new audiences. One of these has been brought about through the transfer of copyright interests from the Maud Lewis Painted House Society to the Art Gallery of Nova Scotia. With this transfer, the gallery has developed reproductions of Maud Lewis images, which will be sold to generate funds needed to further promote the project.

Untitled, 1965
Oil on particleboard
29.2 x 34.3 cm
Collection of Bob and Marion Brooks

Maud Lewis is a Nova Scotia icon and a national treasure. She embodies the free spirit of folk artists working outside the mainstream, liberated from preconceived notions about art. By creating work that brings joy and reflects simplicity, Maud Lewis succeeded in illuminating the best of the human spirit.

Bernard Riordon
Director, Art Gallery of Nova Scotia
August 1996

Recollections
Preface

When my sister and I were young, we lived in a creaky old farmhouse on the beach at Barton, Nova Scotia. As we lived close to the water, our parents kept a canoe on the edge of the little orchard that served as a lawn. On quiet evenings we used to paddle along the shore. One day, my sister surprised everyone by drifting out with the tide on an inner tube. Fortunately my mother was a powerful swimmer and dove into the waters of St. Mary's Bay to retrieve her. Almost half a century has passed, and Barton is still a cluster of farmhouses and fields on Highway No. 1, between the coastal towns of Digby, sixteen kilometres to the east, and Yarmouth, ninety kilometres "down the road." Other villages along the bay, like Marshalltown, Jordantown, Brighton and Weymouth, run one into another and, like Barton, were home to descendants of Acadian, United Empire Loyalist, or Irish and Scottish settlers. For all the hopes and labour of the generations that invested their toil here, none of the villages were prosperous when we were growing up. The farms were small and the soil thin. The fishing was subject to cycles of high and low prices, abundant and meagre catches, while lumbering provided, for the most part, only a subsistence living. It didn't matter whether your father was a farmer or a fisherman, Digby County was a hard ticket.

When we lived in Barton, we were poor. Our father had taken a trip or two on the gypsum boats before signing up for World War II. He was a navigator in Wellington bombers in the 1940s but while overseas he contracted tuberculosis and became a "lunger." After the war he was away in "the San." On winter mornings, my mother and I used to go out to the barn on the old Barton place and strip shingles to start the kitchen fire.

There were no towns to speak of in this rural district. And since one village looked much like another, with their rose-laden fences and post and beam houses, a visitor might only know for certain where he was by checking the names on the innumerable churches. There were some marvellous and strange things in this congenial countryside, not the least among them, Maud Lewis. To my childish eyes she personified much that was alluring and yet strange in the world.

Maud lived with her husband Everett in a little house so close to the Marshalltown roadside that a truckdriver could roll down his window and toss a

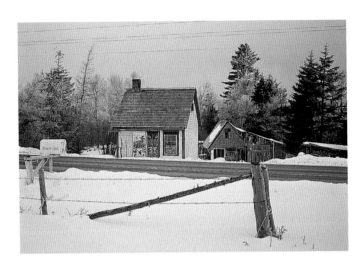

The Maud Lewis house, 1965.

cigarette through the door. They were an odd three-some—wife, husband, and house. Everybody knew them. Few came to call.

The house was truly not a house at all but a little cottage of hand-hewn beams and boards, covered in spruce shingles, and with only three windows to the world. It measured 3.75 metres by 4 metres (12 1/2 x 13 1/2 feet) and consisted of one room with a loft above. Built with an adze and an axe, there was not a straight line to be found in the whole structure. It was so small that the tall, thin Everett nearly scraped the ceiling with his hair. However, the house did befit the little hunch-back Maud, who could be seen most days in the window smoking a Cameo.

While their demeanour was eccentric enough to gain them a reputation as country oddities, there was something delightfully unusual about the colourful sight that greeted every passing car: Maud had painted the window panes of the little house with bright daffodils. And when she ran out of room on the windows, she painted bluebirds on the storm door, and butterflies and swans on the inside door. Strangely, the black swans were in near embrace while the white swans were in opposition.

To top it off, Everett had climbed up on the roof and painted the wooden shingles around the chimney bright red, the colour of brick. In addition to the painted decor of the house, Everett grew high clusters of colourful sweetpeas, both about the little house and inside, in tin cans on the windowsill. The colours were so intense you had to look closely to distinguish the painted from the real. When Maud hung out a "Paintings for Sale" sign with red-breasted bluebirds and pink apple blossoms, the effect was astonishing. Drivers slowed down to enjoy this fantastic sight. Sometimes they stopped to purchase a painting or a card from the resident artist.

To my sister and me these curiosities were the stuff of fairy tales. Everett, sure-ly, was the Crooked Old Man in the Crooked Little House. And Maud Lewis? She was the Witch of *Hansel and Gretel*. We would not have entered her bright little house for love nor money. We would have hidden in a ditch had we seen her coming up the road.

Maud and Ev became part of our local folklore, together with the lady in logger's boots, who endlessly circled parked cars in search of her drowned brother, and the crazy boy who strapped the door of a '38 Ford truck to his

bicycle, and opened it whenever the Mounties stopped him. These were images that endured from our growing-up years, as clear in our minds as the three highway landmarks of our village—the Church Steeple, the Maud Lewis House, and the Poor Farm.

The first person to speak well of Maud Lewis to us school kids was Kaye MacNeil, our history teacher. She was Maud's "secretary" and mailed her paintings to buyers far afield. On one of those endless Friday afternoons she introduced us to Maud's artistic achievements.

For many years Everett was night watchman at the Poor Farm. About the time the institution closed, in the 1950s, and Everett became unemployed, my father had become a lawyer and Maud's patron, buying and promoting her paintings. When we went to pick them up, I was amazed to see that the interior of the house was decorated with the same swans, robins, and flowers as the exterior. There were cornflowers on the steps to the attic, daisies on the cast iron stove, and a little burro and siesta scene on the side of a desk. Maud's paintings were drying, propped up around her, where the light of the window could catch them. On a rainy day the new ones sat on the warming oven of the stove. Their colours were enchanting to a child's eye, bright and reflective, like sunshine illuminating a stream bed full of pebbles. Certainly I was attracted by her paintings, but I found the poverty of the house and the disfigurement of the painter repulsive. Besides, the house smelled of paint and turpentine, and the spruce "slabs" they burned in the stove.

My father was among the very few of Maud's regular customers to commission her to paint specific scenes. One such painting was of my sister with her Christmas presents and another, a portrait of my brother Max beneath a Christmas tree. I thought my father's interest in Maud Lewis a waste of time and money, and I resented the gifts of fine cheese and other treats he took her when he went to pick up the paintings. We had moved into Digby and I had become a snob. When my father asked if I wanted to come with him on his visits to Maud, I said "yes" only on the condition that he bought me an ice-cream at the Dine and Dance.

I was quite surprised when Maud appeared on television, the subject of a CBC *Telescope* broadcast in 1965. I was astonished when Premier Robert Stanfield came to Marshalltown to visit the Lewises. The status of Stanfield in Digby, in the 1960s, was impressive: not quite God, but pretty close. Most startling of all, two of Maud's paintings were ordered by the White House during the presidency of Richard Nixon in the 1970s. I couldn't believe it; but it was all there in the *Digby Courier*.

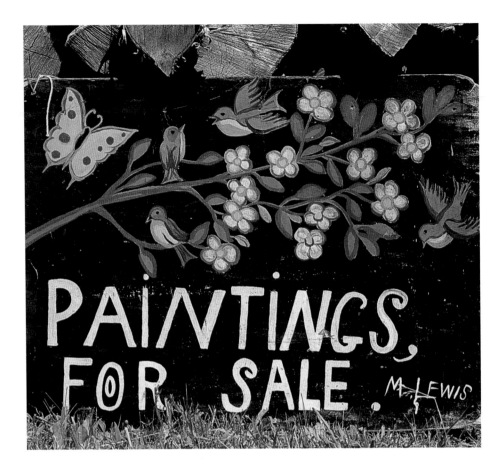

I felt no regret when Maud died an untimely death. I did not appreciate Maud Lewis as an artist, nor had I any inkling of her legacy to Nova Scotia.

Maud Lewis died in 1970. My father had become a judge and I was in Europe. I was thrilled to see Rembrandt's *Nightwatch* at the Rijksmuseum and delighted to be in the Louvre with the *Mona Lisa*. Both masterpieces were familiar to me from cigar wrappers: I didn't know much about art, but I liked to smoke.

I expected the work of Vincent van Gogh to look like that of other Dutch and Flemish masters, but, of course, there were few similarities. His paintings appeared extremely simple; I could actually see the splashes and waves of pigment. A child could do this. Could these simple paintings be what everyone was talking about? I was astounded! Why, they were no more intricate than the crude little efforts of Maud Lewis! I didn't know what to think.

I spent the rest of that summer travelling from gallery to gallery, but I could not forget the van Goghs. They were a revelation. His farmers and cattle were as engaging as Maud's children and oxen. When I returned to Nova Scotia, and went walking in the fields or under the wild cherry trees of Acacia Valley, these

were the images that came back to me, not the dark canvases of Rembrandt or the misty efforts of Turner.

I began to wonder about the Maud Lewis paintings that my father had commissioned. One day my mother and I took them out of storage, unwrapping them from the yellowed newspapers and revelling in the act of bringing them again into the light of day. They were unframed but we began to assemble a makeshift gallery, hanging them with butcher's string by tying knots every metre from ceiling to floor, and slipping the paintings into the loops. When forty had been carefully "hung" we stood back and were overwhelmed with the kaleidoscope of colours, like a beach fire made with driftwood. Strange colours leapt out as they were illuminated by the sunlight streaming in through the windows.

My mother and I wrote an article about Maud's life and sent it to *Chatelaine* magazine. We were rewarded with a cheque for $700. I was thrilled; my only previous success had been £5 for a poem in *The Countryman*.

Later, searching for a story to accompany the paintings, I began arranging them by season, moving them back and forth in the strings, the winter scenes on the left, the summer ones on the right. I saw that Maud had captured every happiness in Digby County: every trade—a fisherman hauling lobster traps, a farmer plowing a field, a blacksmith in his forge; every place—the little bridge and brook in Acacia Valley, the old wharf in Barton, the lighthouse at Point Prim; every animal, flower and bird—cats in the tulips, oxen under the summer bower, robins in the apple blossoms.

Two stories emerged from the scenes of horses and oxen and the curving country roads. They were published, in 1979, under the titles *Christmas with the Rural Mail* and *From Ben Loman to the Sea*. "Lucky Digby to be so immortalized," read a review of these little books, the first in Canada to use folk art as illustration. Seventeen years after their first publication, requests for autographed copies continue to arrive from tourists who do not realize that Maud is dead.

After Everett's violent death in 1979, Maud and Ev's little house was removed from its site by the highway. Nothing remained to show that Maud Lewis ever lived in Digby County. Even her gravestone read "Maud Dowley."

A few years ago I met again an old family friend, the accomplished photographer Bob Brooks. He had visited Maud and Everett in 1965 and had taken a series of portraits of their life together in the little house in Marshalltown. We decided to collaborate on a biography, one that would support the renewed interest in her work and the Art Gallery of Nova Scotia's efforts to conserve the little house. This book is the result. It features many of the Maud Lewis paintings

assembled by the Gallery in conjunction with a national travelling exhibition of her work. This biography is the first comprehensive presentation of the life and art of Maud Lewis, and will serve, we hope, as a fitting memorial to her and an inspiration for others to further study and document her rich and joyous legacy.

L. G. W.

The Illuminated Life of
Maud Lewis

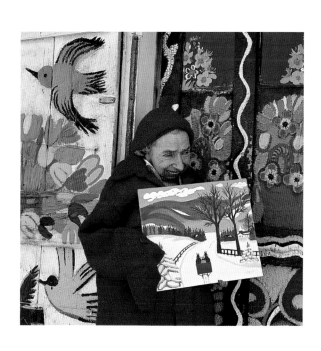

Country Beginnings

*N*ova Scotia is a rural province, as far removed from the great cities as any back-to-the-lander might wish. Yet when a Nova Scotian wants to call up the name of a faraway place, he is likely to turn towards Yarmouth, a county of fishing and farming communities, home to such names as Hebron, Hectanooga, Chegoggin and, the birthplace of Maud Lewis, South Ohio. These communities lie nestled around lakes and tidal rivers that are born from streams emerging out of bog barrens the colour of tea. When the tide comes in, these rivers run green; when the tide goes out, they change to tannin brown.

Maud Lewis was born on March 7, 1903, the only daughter of John Nelson Dowley and Agnes Mary Dowley. Her brother Charles was six years older and the apple of his father's eye. Maud suffered from multiple birth defects that left her shoulders unnaturally sloped and her chin resting on her chest. Her mother nurtured and protected her with extra care from the day she was born. The two children who followed Maud into the world did not survive more than a few days.

Maud's earliest home was a farm. Jack Dowley, a broad and powerful man, was a harness maker and blacksmith who worked for himself and became moderately prosperous. The lowliest tenant farmer with one plough horse and the richest timber baron with dozens of fine draught-horses arriving by rail each fall from the Canadian West required his services. The Yarmouth economy was built on forestry and fishing, making it the seventh largest port in the world by tonnage registered.

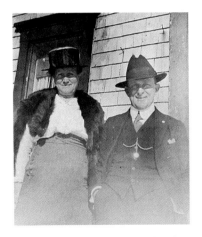

Maud's parents, Agnes Mary Dowley and John Nelson "Jack" Dowley.
Collection of Nellie Muron

Facing page:
Untitled, undated
Oil on particleboard
30.1 x 36 cm
Collection of Dr. Douglas E. Lewis

The woods in those days were full of lumber camps, and the harness maker equipped the oxen and horses that hauled the logs out of the woods to the mill, and the lumber from the mill to the waiting ships. Each harness was an individual construction, and the best were elaborately decorated. John Dowley worked with the tools of his trade—awls, clamps, needles and a crooked knife. He was a respected craftsman.

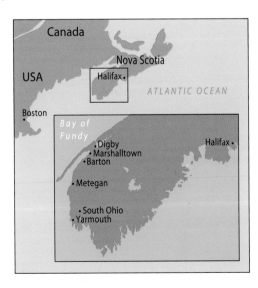

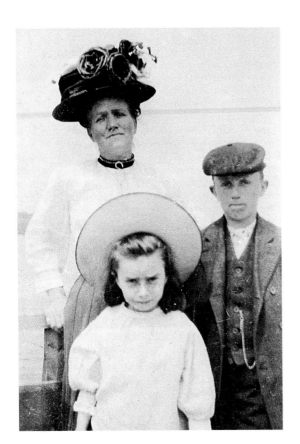

Agnes Mary Dowley, Maud Dowley
and Charles Dowley.

Maud's mother Agnes was a Germaine from Digby, Nova Scotia. She was a tiny strawberry-blonde who liked lavender perfume. She wore elaborate hats and silk scarves, and displayed a fondness for black patent-leather shoes. She shared her love of music and her ability to play the piano with both of her children. Charles was an accomplished dance band musician. Agnes' relatives, the Germaines and the Sullivans were lumberjacks and stevedores who possessed a talent for painting and folk carving. Maud's creative abilities were not unprecedented in her family.

Agnes liked to play double solitaire with other ladies, the two players laying out their cards as they faced each other across a kitchen table. Perhaps the quietest of card games, double solitaire is dealt and played with two decks at once, and each game in the Dowley home was followed by tea. Agnes was said to be competitive at cards and to have devised her own system of holding the cards in her lap so they might be reshuffled if the order was not as encouraging as her companion's. Maud's quiet and clever nature came from her mother.

Maud received her first instruction in art from her mother who taught her to paint Christmas cards, which they then sold door-to-door. Taking one's wares directly to the buyer, be they mayflowers, Christmas wreaths or ash splint baskets, was not an uncommon way to supplement a family income in the 1900s. To hand-paint cards may seem to us a laborious way to earn Christmas money, but then even photographs were tinted by hand.

Agnes charged five cents for her colourful cards, the same price Maud later charged her Digby County customers. Agnes and Maud painted their watercolours on rough paper, the kind that filled a student's unlined scribbler. When Maud recalled her childhood instruction, she mentioned using crayons: "I used to paint with crayolas a lot, kind of practicin' up I guess." None of the early cards painted by Agnes and Maud have been found, but they likely resembled the cards, later acquired by Maud Lewis collectors, that Maud and Everett sold door-to-door in Digby in the 1940s. In preference to the festive scenes that we have come to expect on Christmas cards, Maud depicted the animals and birds likely to be found in the Yarmouth County of her childhood.

Agnes also taught Maud the unusual technique of wrapping sprigs of braided wheat with metal foil. Wheat sheaves, marsh hay and barley were common in Yarmouth. The foil came from cigarette packages. One of Maud's Christmas foil

creations was treasured by its owner for nearly twenty years before it fell apart. Maud continued to make these Christmas decorations throughout her youth and into her adult years. Those who watched her fashioning these decorations considered it remarkable that such twisted fingers could form these intricate foil and wheat bouquets.

By all accounts Maud was a happy child, bright-

Untitled, undated
Watercolour and ink on paper
8.5 x 13 cm
Private collection

eyed, talented and eager. It is indicative of the relative prosperity of the Dowley household that they owned a piano and a phonograph. "Them days gone by," she recollected, "we used to have one of them phonographs with records, a big round horn." There were few signs of poverty in Maud's childhood. Although her mother ran a frugal and self-sufficient household, it was only later in Marshalltown that Maud was to experience poverty and parsimony.

A 1967 article by Doris McCoy, published in the *Atlantic Advocate,* suggested that "Maud had been stricken with polio, which left her arms and hands crippled," but this seems doubtful. Her twisted and crippled fingers, her deformed chin and bent frame were more likely the result of birth defects. An early photograph of her standing at the farmhouse door with a large white cat in the foreground illustrates these physical characteristics; yet her magnetic smile and gentle nature shine out with cheerful clarity.

Maud's attendance at a country school in South Ohio was irregular. Records show that she completed Grades One, Two, and Three by the time she was eleven; Grade Five or Six would have been a standard performance by that age. We do not know if Maud's academic record was weakened by her own ill health, or by the fact that, in those days, country schools in Nova Scotia had difficulty attracting teachers.

Happily, Maud's childhood home in South Ohio was filled with loving parents, pets, music, and painting. She fondly remembered this time when her

family was together. In one interview years later she spoke of their excursions on a Sunday afternoon: "We used to go on beach picnics, the whole family; they're all gone now."

This happy period of Maud's life created the lasting impressions that later formed the basis of her life's work.

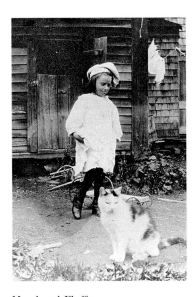

Maud and Fluffy.
Collection of Nellie Muron

Right: Maud's cats were always named Fluffy. Cats and flowers were her favourite subjects.

Untitled, undated
Oil on particleboard
35.7 x 30.7 cm
Collection of Donna Cameron

Facing page: Maud recollected her childhood home in South Ohio as unspoiled and idyllic.

Springtime, undated
Oil on particleboard
28 x 30 cm
Collection of Shirley Robertson

Cast Away from Home

*I*n 1914, when Maud was eleven, she moved with her family to the shire town of Yarmouth. Her father established his harness shop in a shed on Jenkins Street, near the waterfront, and they rented a house on Hawthorne. For many years, Dowley's Harness was a prosperous little business, like others in the neighbourhood—the Minard's liniment shop, the telegraph office and the lobster buyer. Jack Dowley could look out his front door and see the ferry coming in; if he was too busy to look up, he still could hear the whistle. Yarmouth was then and remains today an important Nova Scotia seaport, enjoying fine schools and a regional hospital. It has long been known as the Gateway Port—the most popular port of entry to Nova Scotia from "the Boston States."

Dowley is remembered in Yarmouth as a quiet man who went about his work in a steady, serious way. When the gasoline engine became king, he adapted his trade from harness making to other forms of leather work—the repair of leather or canvas goods—a lady's handbag, a sailor's duffel, a traveller's grip. As owner of the shop, he often employed an apprentice. He earned enough money to heat the Dowley home with anthracite, a hard coal imported from England that was of much better quality than the soft, brown and smoky coal mined in Cape Breton. He provided a comfortable living for his family of four.

In towns like Yarmouth, the ability to recognize members of a younger generation by family resemblance is a sign of one's long-standing connection to the community. But anyone using conventional wisdom on the Dowley family would have been as struck by their differences as their similarities. Jack is remembered for his mild patience and cheerful manner, while Maud's mother, Agnes, was shy and withdrawn. She was not given to carrying on long conversations or making jokes, and seldom left the house.

Their son Charles was, however, a social dynamo, attractive to women, manager of the Capitol Theatre on Yarmouth's Main Street, and saxophone player in the Gateway Four. Every man in Yarmouth knew "Charlie," and there are still some women in town who remember Charles and his charm.

And then there was Maud, a little elf, bearing the burden of physical disfigurement. Maud left school at the age of fourteen after completing Grade Five. It seems likely that illness and her physical deformities played a role in this decision. Children made fun of her in the streets and mocked her flat chin. The

Facing page: **Maud's father Jack was a blacksmith and harness maker. Maud's teams are always properly harnessed, and decorated.**

The Blacksmith, undated
Oil on board
22.8 x 30.5 cm
Collection of the Woolaver family

THE ILLUMINATED LIFE OF MAUD LEWIS

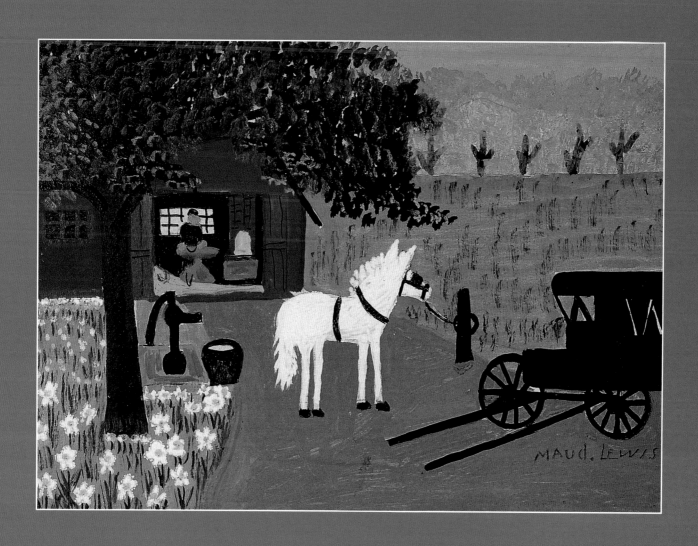

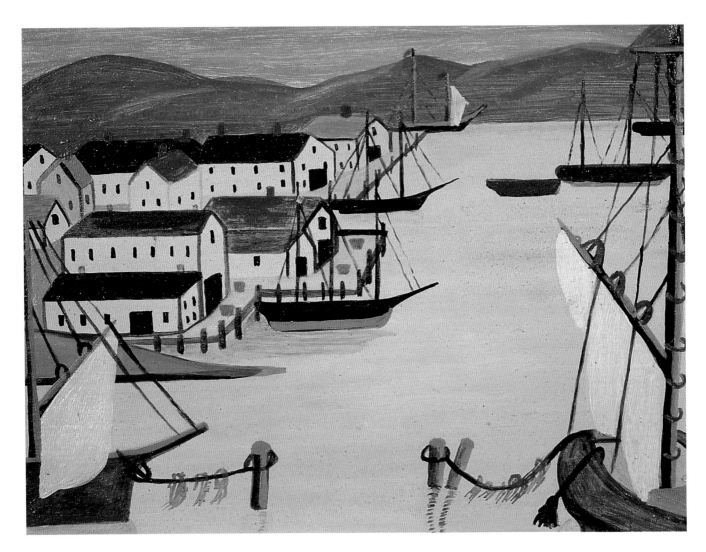

This seascape of the Yarmouth docks is Maud's earliest known oil painting.
Untitled, Circa 1948
Oil on particleboard
23.2 x 30.5 cm
Collection of John and Jane Wightman

Facing page: Maud's home counties of Yarmouth and Digby are famous for their fishing fleets.
Untitled, Circa 1963
Oil on particleboard
22.5 x 29.1 cm
Collection of Carole Regan

twenty-minute walk from Hawthorne Street to school was an ordeal; she often went to her cousin Eva Gray, a school teacher, for comfort.

Although Maud never held a job, as her schoolmates did, in the shops of Yarmouth, there were compensations. Under the loving care of her mother she learned to play the piano, and continued to do so until her fingers became too misshapen. She seldom went out, occasionally attending movies at the Capitol, courtesy of brother Charles, walking there and back with her mother. She did not go to dances or parties, although her brother Charles attempted to include her in his activities. One such occasion was the Green Island picnic, when Maud went with Charles, his wife Gert and several other young couples. They hired a fishing boat at a cost of fifty cents apiece. The fact that Maud was able to climb up and down the wharf ladders disputes any suggestion that she was "crippled." She may

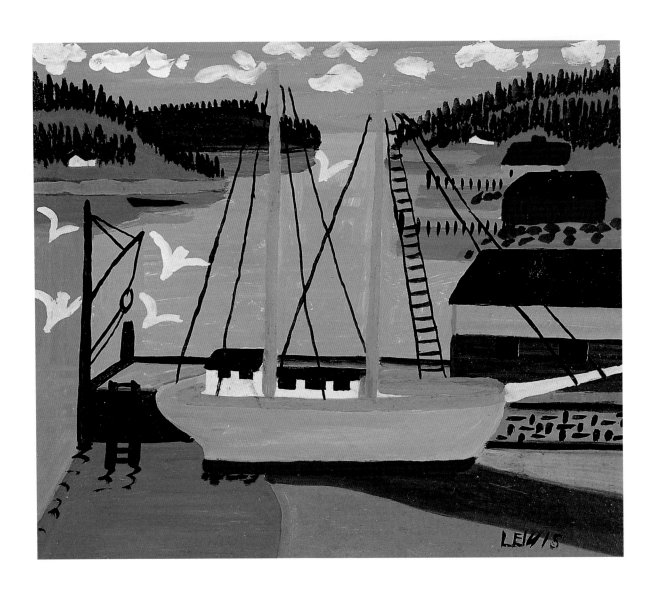

THE ILLUMINATED LIFE OF MAUD LEWIS

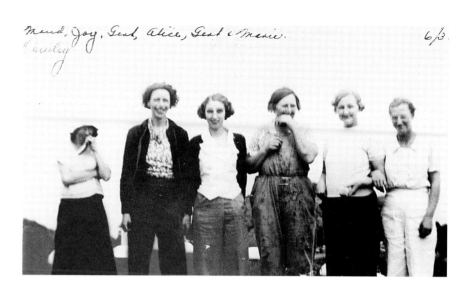

Maud, Joy, Gert, Alice, Gert & Marie. 6/3

have been disfigured, but she was physically capable of scrambling over the side of the boat and enjoying the outing. In Yarmouth the wharf ladders consisted of iron rungs fixed into oak or spruce timbers; the thirty-foot rise and fall of the tides often left a daunting climb. Whatever the tide may have been that day, Maud apparently experienced no difficulty with the rigours of the excursion.

Photographs of the girls show Maud in a long, dark dress. The "modern" girls wore slacks, and one lady, evidently the comedienne of the group, wore overalls. Still, the photograph shows Maud alone, separated from the other girls and hiding one hand under her elbow.

There were many who liked Maud and regretted the teasing she suffered. Her friend Mae Rozee, who became a beautician and operated a ladies' beauty salon, would take Maud's cards and decorated trays to sell in her shop. She put them in the window and gave Maud the money after the items had sold. Maud greatly valued their friendship and wrote in Mae's autograph album: "What is life without love or friendship?" This poignant remark is an insight into the side of Maud that is least accessible. Like many shy and creative people, Maud expressed her hidden feelings in her work. Her cards and later her painting provided outlets for her deepest emotions.

The last years of Maud's youth came and went in the comfortable home on Hawthorne Street. Perhaps it was expected she would remain there and be a companion and helper to her parents in their old age. In 1935, however, the pattern of Maud's life changed dramatically. Jack Dowley passed away and her mother's death quickly followed in 1937. For a brief time Maud lived with Charles and his wife Gert. Then, unhappily, "Charlie" left Gert for another woman and the family home on Hawthorne was vacated. Charles was anxious to get Maud "off his hands" and hastily sent her "up the Shore" to stay with Aunt Ida Germaine in Digby. As was remarked in Yarmouth, "He didn't have her too long and then shipped her up to Digby."

Any inheritance that remained from the settlement of the Dowley estate stayed in Charles' hands. Maud received no legacy and few personal possessions

Maud Dowley, extreme left, on an excursion to Green Island, Yarmouth County, 1935.

Facing page: This fishing schooner has been left on the mudflat by the receding Bay of Fundy tide.

Untitled, Circa 1963
Oil on particleboard
29 x 34.4 cm
Collection of Carole Regan

from the family home. Not only had she lost both parents, but Charles, the last surviving member of her immediate family, was unwilling to assist her. Charles was in some difficulty in the late 1930s and used the Second World War as a means of extricating himself from his marital problems. When he returned from overseas he set up house in Halifax and never saw nor spoke to Maud again. He did visit their Aunt Ida in Digby on one occasion but failed to travel the four miles to Marshalltown to visit his sister.

One cannot help but wonder what caused the rift between the brother and sister who had, apparently, enjoyed a warm relationship while their parents were alive. Charles appears to have been insensitive to Maud's vulnerability as a single woman and more especially to her incapacity to support herself, taking steps to separate himself from any responsibility for her well-being. This painful episode

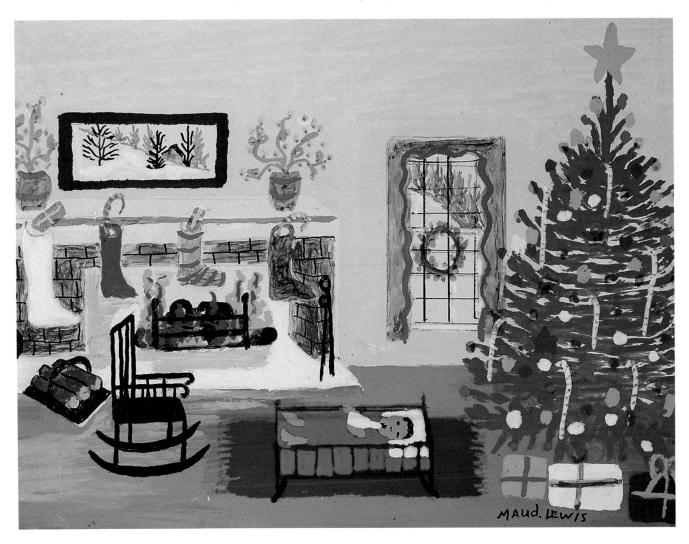

becomes tragic when one learns Maud bore a child out of wedlock around this time. Several Yarmouth citizens who knew the Dowleys recall that Maud Dowley gave birth to a baby girl the same year her mother died. The baby was adopted and grew up in Yarmouth County, never knowing her natural mother. She later married, and passed away several years ago. No details are available as to the circumstances of Maud's pregnancy, and as the child was adopted, birth records are not available. To understand the effect this event may have had on Charles' and Maud's relationship, one must remember the stigma of bearing an illegitimate child sixty years ago. "Unwed mothers" were often shunned by family and friends, denied dignity and social rights. Children were hastily given up for adoption and information about their natural parents went unrecorded. Maud's pregnancy may have been the catalyst for Charles' abandonment of her.

In 1965, when Maud was interviewed by an admiring journalist, she implied that Charles was dead, although in fact he outlived her by two years. Maud never spoke of her family to her Marshalltown neighbours. It was as though they had never existed.

A Wedding Without Bells

I t has been erroneously reported that Maud Dowley married Everett Lewis when she was eighteen. If this were true, she would have met and married Everett when she was living in her parents' home in Yarmouth. However, a certificate from the Province of Nova Scotia confirms they were married in the village of Barton on January 16, 1938, when Maud was thirty-four years old.

At that time, young women in rural Nova Scotia were expected to marry before their twentieth birthday, and often did so at the age of sixteen or seventeen. Maud, now in her thirties, was said to be "getting along" and given her physical appearance and social standing, her prospects were limited.

Everett told the story of their "courtship" many times, though not always in the same way. Apparently he never told the whole story. According to his version, they first met in 1937 when he posted an advertisement in the local stores letting it be known that a forty-four-year-old bachelor was looking for a woman to "live-in or keep house." No mention of marriage was made. He owned a little house, shingled and painted white, a piece of land and a Model T Ford.

Their meeting, however, was largely Maud's doing. Shortly after Everett's advertisement, Maud left Aunt Ida's house in Digby and walked through the village of Conway to the highway, then along the train tracks to Marshalltown. She arrived at the little house next to the Poor Farm and knocked on the door, unexpected and unannounced. According to Everett, he was undecided about her overture, but his dog knew immediately that Maud was to become a permanent addition to the household. "I kept a dog then, a pretty sharp dog, who wouldn't let anyone into the house. But when Maud came, he never said a word. Now ain't that funny?"

There were no other applicants, but Everett was slower than the dog in making up his mind. Although he owned a car, Everett did not offer to drive his visitor home that night: "I walked with her as far as the railroad underpass, 'cause it was dark, and let her walk the rest of the way alone." The railroad underpass he spoke of was about a mile from his house. Maud had to scramble up a thirty-foot bank, in the dark, to make her way back to Aunt Ida's. "The next day I passed her on the road but I didn't pick her up."

But something must have passed between them that made him change his mind: "Well, a couple of days later she come down again, and that time I drove

Facing page: The Wedding Party.

The Wedding Party, undated
Oil on Eaton's artboard
27.9 x 35.5 cm
Collection of the Woolaver family

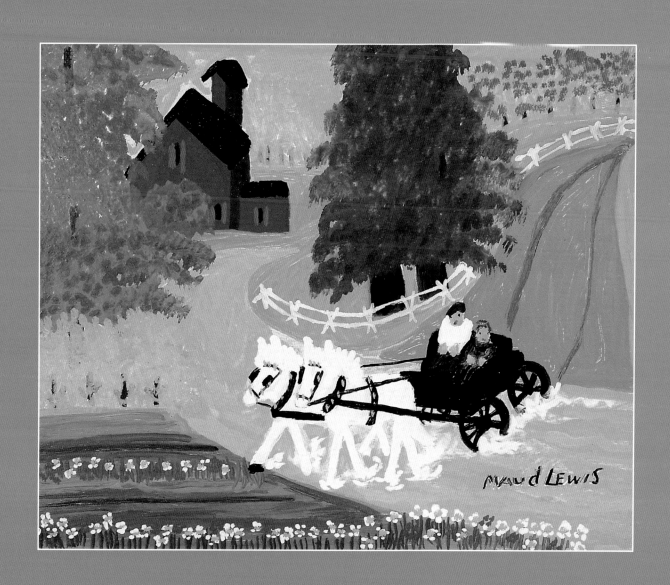

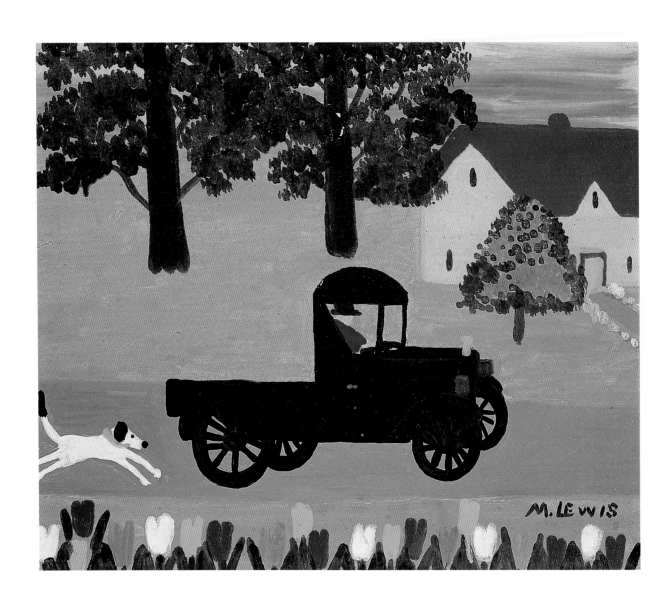

her home. And then we was married and she come here to live."

Maud had little to bring into the household. There was no dowry and she had no money; she was unable to cook in a lumber camp, or cut fish in a fish plant to "put something by," as many Digby women did. Poor as Everett was, his possessions were greater than hers.

They were married within a few weeks of Maud's journey from Aunt Ida's house in Digby to Marshalltown. Everett later remembered this as being within a week of their first meeting, but it is unlikely that a marriage licence and a minister could have been obtained within a week. And, as Everett himself said, he took a bit of time making up his mind.

He did have one concern unrelated to money. Maud's cousin, Mrs. George Gavel, remembers that Everett came to talk with Maud's kinfolk before the marriage, inquiring about her hands and the cause of her illness. "He came to my place to find out why her hands were crippled," Mrs. Gavel remarked. This may be the origin of the story that Maud had suffered from polio. Satisfied that Maud's condition was not contagious, Everett married her.

For Maud to walk six miles to the home of a man she did not know seems out of character, given her shyness and the customs of the time. The story of the dog declining to challenge Maud's arrival helps support Everett's account of himself as a not-too-easy catch. However, there are other accounts of their marriage that differ from Everett's.

Maud was not the first "orphan" to enjoy the generosity and kindness of Ida Germaine. Many people were taken into her comfortable home, among them Maud's cousin Arthur Sullivan. It was Sullivan who recalled, "Aunt Ida didn't want her to marry Everett … They wanted her to reject him, but Maud was strong-headed. Aunt Ida didn't trust him, and she was a wonderful person, she was a Christian … He came to the house with fish. He knew Maud was there. She knew about the ad."

Maud may have found out about the ad from a young relative of the Germaine family, Arnold Cook, who teased her about Everett wanting a housekeeper. It must have come as a surprise when Maud took him up on it.

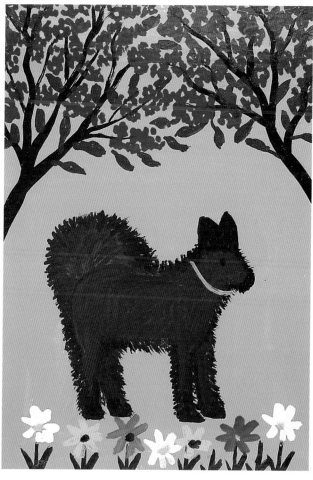

This dog of Everett's, one of many, was named Bill.

Brown Dog, undated
Oil on cardboard
17.8 x 25.4 cm
Collection of the Woolaver family

Facing page: Maud's husband Everett Lewis was an efficient fish peddler.

Peddler, Truck and Dog, undated
Oil on board
22.8 x 30.5 cm
Collection of the Woolaver family

THE ILLUMINATED LIFE OF MAUD LEWIS

Conversely, Free Sibley, who knew Everett Lewis well, recalls that Everett courted Maud, and the Model T played a key role. "They used to meet up here by the gravel pit," Free recalls, "before they was married." Whatever the circumstances that brought them together, Everett probably met Maud several times during his travels through Digby as a fish peddler, and Ida Germaine's distrust probably precipitated Maud's solitary evening hike to Marshalltown.

Although Everett was willing and Maud was lonely, she did have her price. She declined Everett's offer to "keep house" or "live in," insisting on marriage. No one living today recalls their wedding. Maud, herself, however, remarked upon it in one painting, a unique horse and buggy scene, with the tall lanky Everett and the tiny little Maud on a country road, advancing between rows of apple trees and tulips. There are no well wishers present, just the flowers and the blossoms—a quiet wedding.

"I call it *The Wedding Party*," Maud Lewis said to the purchaser of the work.

Facing page: The Dominion Atlantic Railway ran from Digby to Marshalltown. Maud followed the tracks to answer Everett's advertisement for a housekeeper.

A Child's Special Day, Circa 1960
Oil on particleboard
31 x 36 cm
Collection of Shirley Robertson

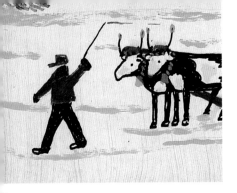

A House Ready for Painting

When Maud Dowley married Everett Lewis, she willingly took a step down the economic ladder. The Dowleys and the Germaines were hard working and moderately prosperous, and Maud was fortunate to have had a few relatives who cared about her and were willing to "take her in." For Maud, Aunt Ida's house was a home-away-from-home. It was not a grand residence, but it was solidly built and neatly kept. There is proof of its quality: it had been moved to St. Mary's Street without suffering damage or misalignment. In comparison, the house Maud moved into with her husband was a cracker box.

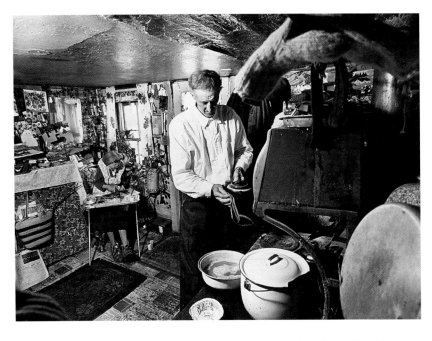

Maud's husband Everett did the housework while she painted.

Everett Lewis had hauled his little cottage to Marshalltown in 1926, shortly after acquiring a piece of land by the highway measuring approximately 45 metres by 40 metres (150 feet by 130 feet) from Reuben Aptt. The land came cheaply: Everett's mother, Mary, who had become Mr. Aptt's housekeeper following her release from the Poor Farm, arranged the deal for her son.

The little one-room house, complete with sleeping loft, was purchased from Son Brown who had obtained it from Captain John Ryan. The exterior and the roof were spruce shingle; there was no foundation.

This was the place that Maud came home to after her wedding. It was to be her home, her studio, and even her "canvas" for the next thirty-two years.

The lack of room and Maud's decorative touches were popular subjects among those who shared an interest in her work. As one observer remarked, "Inside the house everything with a flat even surface was painted with flowers and butterflies. Even the black cook stove was decorated. We were invited to have a seat and some tea, but as Everett wasn't much of a housekeeper, there wasn't a chair that wasn't covered with books, clothes and paint supplies anyway." Nevertheless, this modest structure was to become the focal point for

Facing page: **Maud's oxen wear the Canadian-style head yoke, almost always painted red.**

Under Spruce, undated
Oil on board
22.8 x 30.5 cm
Collection of the Woolaver family

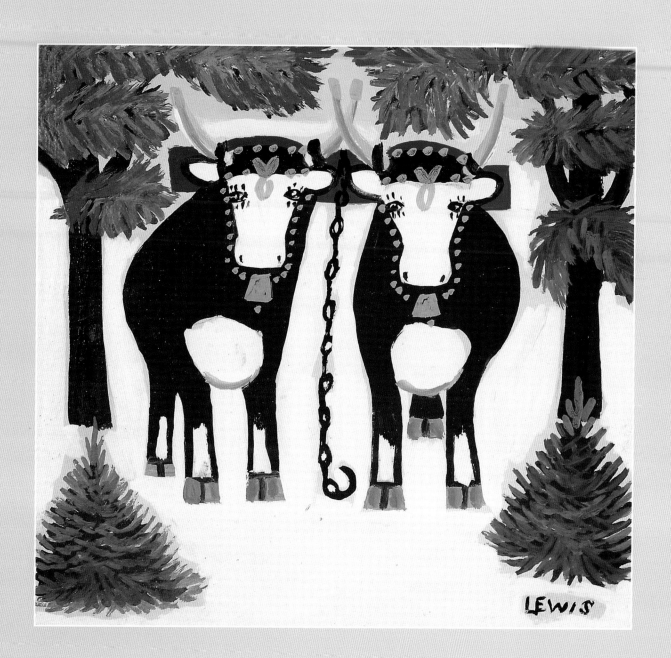

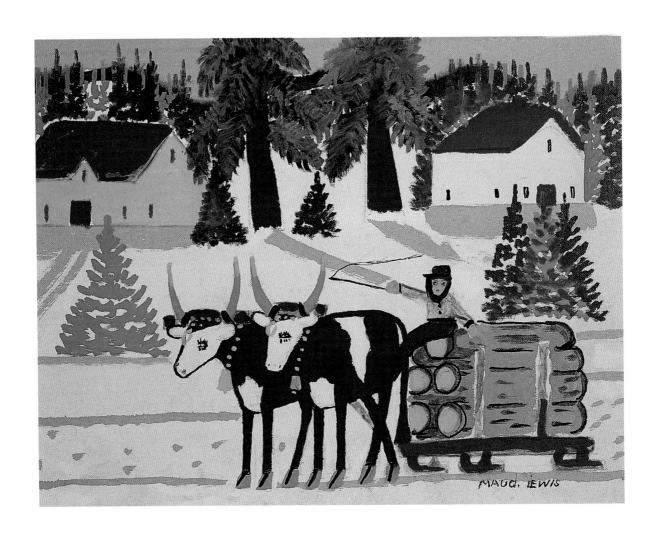

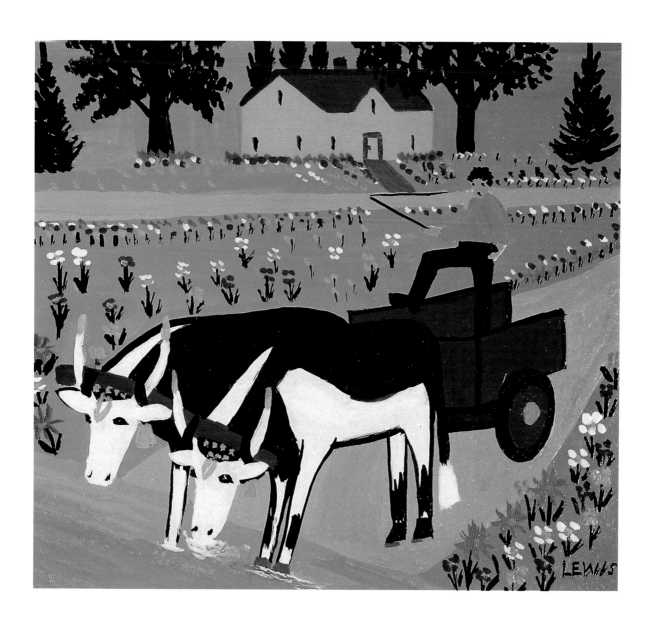

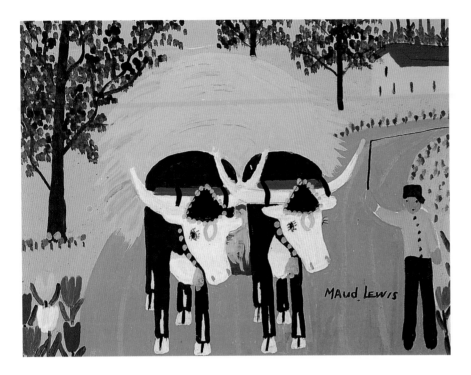

Maud's portraits of oxen show them in all seasons. In fall, they hauled marsh hay from the dykelands to the barn.

Yoke of Oxen, undated
Oil on masonite, 33.0 x 45.0 cm
Collection of John Filliter and Clevie Wall

Previous Spread:

Left: Oxen in Digby County in the 1940s were all-purpose animals. Here they pull a single plough.

Untitled, 1968
Oil on particleboard, 40.4 x 52.8 cm
Collection of Anne Flinn

Right: Maud knew that oxen were notoriously vulnerable to the heat of summer.

Untitled, Circa 1960
Oil on board, 30.5 x 35.6 cm
Collection of Mr. Bruce S.C. Oland

Facing page: A pair of oxen was called a "team" or a "yoke." Maud also painted a single ox at work, colloquially called a "dagon."

Haywagon, undated
Oil on particleboard, 23 x 30.5 cm, Private Collection

a body of work now proudly called the Maud Lewis legacy. It became known as the Maud Lewis House.

Everett could not have purchased a house less suitable for his size. He was a tall, gaunt man and the house had originally been built by Albert Winslow, a rather short bachelor.

With some justification, Everett told anyone who would listen that the house was his, that he had dragged it there by ox team, before he ever met Maud. Somewhat of a braggart, he would grossly exaggerate its size and weight and the number of oxen its relocation required.

"How many oxen you think it took to haul my house?" he would ask his visitors. "Two."

"No, no! Ten! It took ten span a oxen to move it! Fellas came in with oxen. There was the Seeley boys, Burns and Ben. There was Harold Simms and Fred Ryan," boasted Everett. "Hauled it up there from the Flat. When they hooked 'em on it was like they threw the anchor out on the *Hitanic.*" Ten span of oxen yoked and chained to the same load would have been quite an event in Digby County in the 1920s. Twenty powerful animals could have moved a sawmill!

Eventually though, Maud did have a temporary room of her own. Clair Stenning, a Halifax art dealer, had made it known that what Maud really wanted for a studio was a trailer, with enough room for her brushes, boards and oils. Following the *Telescope* broadcast in 1965, Elliott Doucette, a neighbour, brought a little tin trailer to the Lewis' backyard and it was duly set up. It had an oil stove, a table and chairs, and a refrigerator. Maud was unable to paint there in the depths of winter, but it did provide a clean and bright summer studio.

The house may have been Everett's, but the trailer was clearly Maud's. It served her faithfully, until failing health forced her to abandon it. This was the only asset she could claim in its entirety, but strangely, she never decorated it. Perhaps she found its metal surface uninviting, although she frequently painted metal pots, and in one case a metal dustpan. It is unlikely that Mr. Doucette was

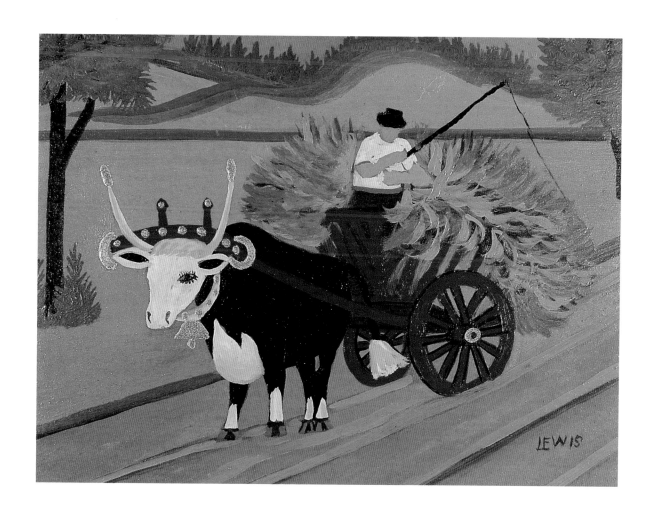

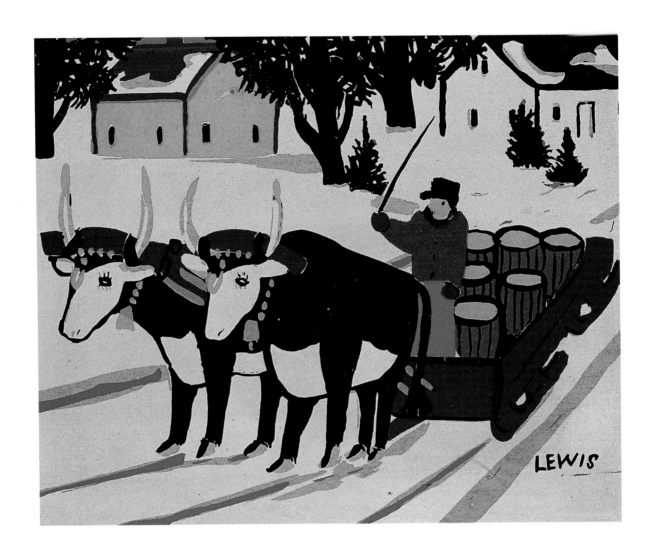

THE ILLUMINATED LIFE OF MAUD LEWIS

paid much for it. Everett's neighbours knew him as a man who "folded bills into one inch squares." But perhaps Maud, who always recognized and appreciated generosity, made a gift of a painting to her benefactor. One of the earliest Maud Lewis paintings on masonite is still with the Doucette family.

Maud's standard of living may have declined after marrying Everett but she didn't seem to mind. She not only willingly accepted the little house as her lot in life, she was pleased and proud to be Everett 's wife. She enjoyed being photographed in front of their home: it was proof positive that she had made something of her life, that she was Mrs. Lewis, a married woman living with her husband in their home—secure, respectable and independent.

"I'm contented here," she said. "I ain't much for travelling anyway. As long as I've got a bit of brush in front of me, I'm all right."

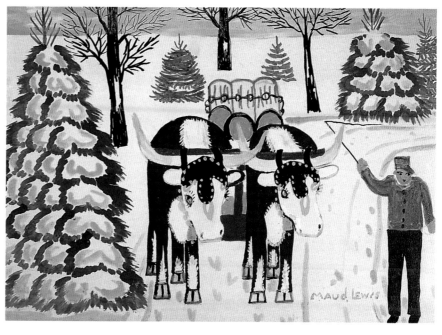

Maud depicted oxen at many tasks. Heavy loads were hauled after the logging roads had frozen.

Untitled, undated
Oil on board
29.5 x 39.2 cm
Collection of Dr. Douglas E. Lewis

Facing Page: A good teamster seldom struck his animals. A yoke of oxen was directed by the *sound* of the whip. Maud has not painted the whip, only the butt.

Untitled, Circa 1947
Oil on board
21.5 x 29.5 cm
Collection of Mrs. R.F. McAlpine

Roadside Business

The arrangement that Maud and Everett entered into at the time of their marriage was a traditional division of labour: Maud would do the cooking and cleaning and Everett would provide her with room and board. By now, Everett had graduated from life as an itinerant labourer, moving from one farm to the next, to fish peddling. His advertisement for a live-in housekeeper was consistent with his open-ended method of bargaining: he would marry the woman if he had to, but not necessarily.

Unfortunately for Everett, his plans for a capable housekeeper were soon thwarted; rheumatoid arthritis twisted Maud's hands into the shape of lobster claws. Gradually, she became unable to grasp heavy objects and had to keep a forked willow rod handy to help her pick things up. It soon became obvious that she was unable to keep her part of the bargain.

As Maud's mother had been an industrious housekeeper, Maud must have keenly suffered her own shortcomings. In truth, her contract to cook and clean would not have been easy to fulfill even if she had been a healthy strapping country wife. There was no pantry in the house, no bathroom or kitchen; no electricity, telephone, or running water. The well was simply a rock-lined hole in the lawn covered by a few boards to keep field mice from falling in. It supplied both the house and the garden, and was also used to keep milk and butter cool.

Maud and Ev slept in the loft, a small triangular space accessible by ladder. On one occasion when Dr. Tony Armstrong of Brighton was called to look in on Maud, he was unable to get through the tight squeeze to the loft and Maud had to be brought down the ladder to be attended. Although the ladder was later replaced by a set of stairs, Maud eventually came to sleep on a sofa by the stove.

The stove was a large cumbersome contraption that constantly required stoking and regular infusions of slabwood. It filled the house with smoke and ash on the slightest down-draught and manipulating the "drafts" required a long reach. What little space remained in the cottage around the stove was filled with the paraphernalia of day-to-day living. Coats hung on the walls; food was stored in bread boxes, and wires hung above the stove to dry mittens and laundry. A sofa and a few chairs were jammed into whatever room was left. In keeping with Maud's taste, bright calendars papered the walls, illuminated after dark by oil

Everett Lewis sawed and split the wood that heated their home.

Facing page: Everett Lewis bought fish dockside, and sold it to the farmers' wives in the nearby towns and villages.

Fish for Sale, undated
Oil on board
22.8 x 30.5 cm
Collection of the Woolaver family

THE ILLUMINATED LIFE OF MAUD LEWIS

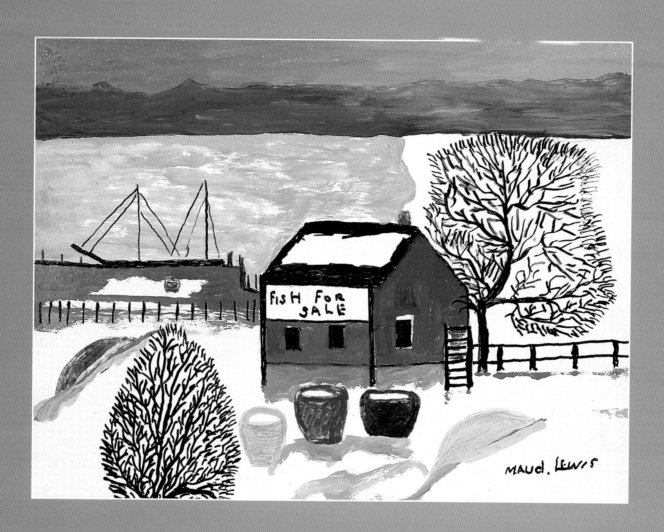

In Maud's farmyard scenes, there are no fences, wires, whips or pens.

Untitled, Circa 1960
Oil on board
30.5 x 35.6 cm
Collection of Mr. Bruce S. C. Oland

lamps. As Everett's sheds habitually leaked, a supply of firewood had to be kept indoors to "warm up." In the three decades of their marriage, Everett made no improvements to the house, despite suggestions from Maud's relations, and despite his substantial savings.

Everett may have felt that he got the short end of the bargain as Maud's advancing arthritis restricted her movements, but he was really quite capable of taking care of their basic needs. After all, he had taken care of himself most of his life. After his father left the family home, he and his mother were made wards of the county and were moved into the Poor Farm. Everett had an unlucky start, and there was more than a little sadness and regret in his recollections. The young boy was boarded out at farms in the area and received food and lodging in exchange for his labour, relieving his mother of this burden.

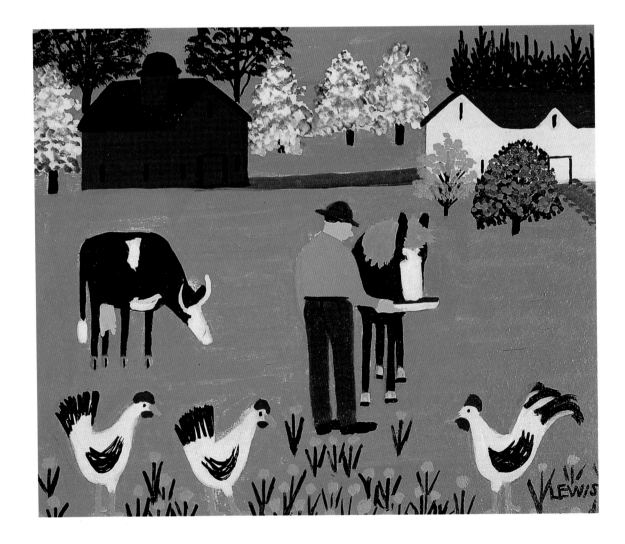

His year began with spring planting and "getting the garden in." It ended with the apple harvest in October. Everett milked cows morning and evening, weeded crops with a long-handled hoe, and tamped down the load on the haywains. One family would treat Everett well and "feed him up," the next would "thin him out." The most pressing concern was to find a place for the winter, some farm where a boy could be useful even when there was was not much outdoor work to be done. In later years he worked at least two winters as a cook's helper in the Mullen lumber camp in Weymouth, where he learned to bake bread.

Instead of "schoolin'" Everett acquired a goodly amount of practical country knowledge. If Maud was unable to bake a pie, Everett could do it, beginning with picking the apples from abandoned orchards. He knew how to fashion rabbit snares out of copper wire and set them along rabbit trails. He knew

Net mending may still be seen at the Long Wharf, Digby, N.S.

Untitled, Circa 1960
Oil on board
30.5 x 35.6 cm
Collection of Mr. Bruce S. C. Oland

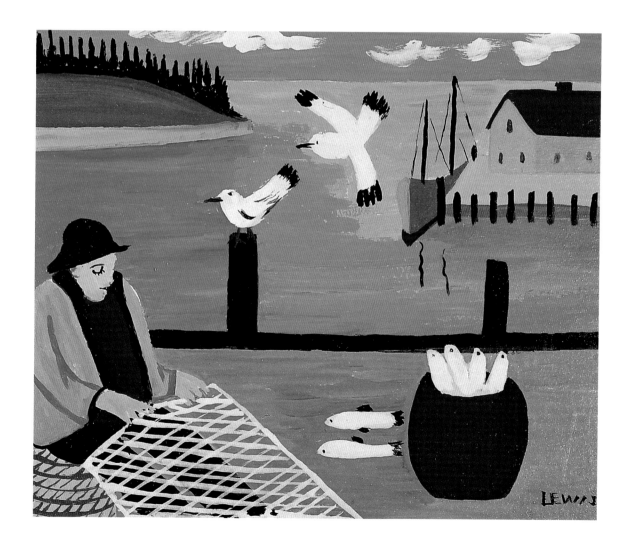

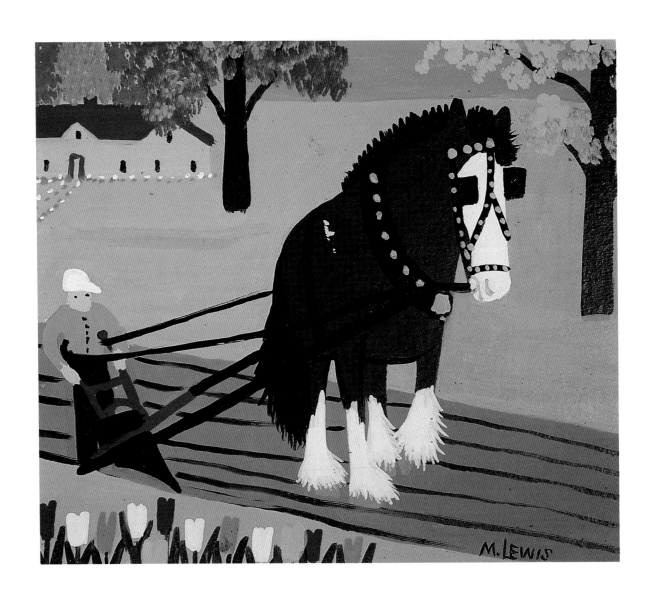

THE ILLUMINATED LIFE OF MAUD LEWIS

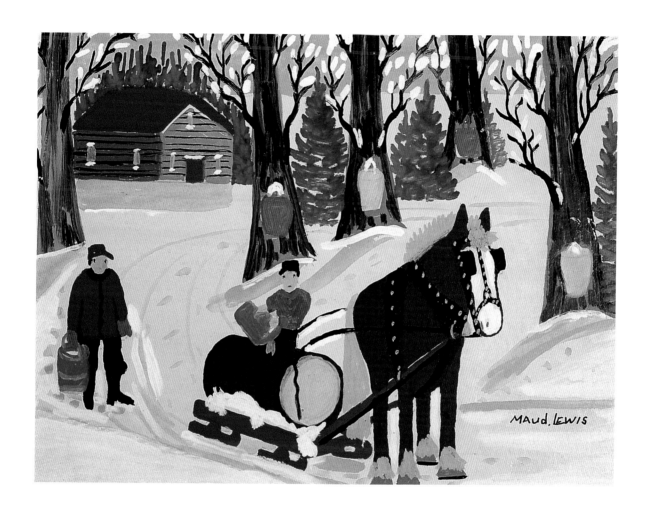

Left: This autumn field is being prepared for a late planting in the unlikely company of spring tulips.

Untitled, undated
Oil on particleboard
30.1 x 34.9 cm
Collection of Dr. Douglas E. Lewis

Right: For this lucky draught-horse, gathering sap for maple syrup must have been a welcome break from the winter barn.

Untitled, undated
Oil on board
39.2 x 52.4 cm
Collection of Dr. Douglas E. Lewis

when the smelt were running and would dipnet them from the tidal brooks for "a good feed or two." When the smelt run was over, and the "brookies" ended in the fall, there were razor clams at Barton, and quahogs as big as plates at the Head of the Bay.

Everett was a master scrounger with the ability to pose as a man without means. If he didn't get something for nothing, then he got it for next to nothing. He scrounged his home and the means to heat it. Everett had been working for a local farmer and sleeping in the barn when he found the stove. It had been dismantled, so he could move it piece by piece to the little shack that he was making into a home. He bolted it together and, luckily, found useable grates on the dump behind the Poor Farm. It had a warming oven above the cooking surface, and a tank for heating water. When Maud moved in, she decorated it with yellow daisies.

Behind and around the house, Everett constructed a little community of ramshackle sheds, including an outhouse of the standard uninsulated variety.

There was also a shed for chickens, a run for the dogs, and a little workshop where Everett cut rough carpentry. All the sheds leaned one way or the other, like cardboard boxes left out in the rain. Everett never bothered to go to the expense of shingling them. For the most part they were covered in tarpaper tacked to the boards by lathes.

Everett had had enough of farming as a young man and wanted no part of it for the rest of his life. Nevertheless, he scrounged an enormous assortment of tools, including scythes, saws, files, and scrapes, hoes, spades, forks, and hacks, adzes, and axes. As often remarked, he had more tools and did less with them than any man in Nova Scotia.

There was a pretty little stretch of grass behind the house that Everett kept neatly trimmed with a scythe and clippers. Maud liked to sit out there to watch the butterflies and admire the sweet peas, which clambered up their wires and strings, beyond her reach. The flowers, coaxed into bloom with the assistance of free fertilizer from the beaches of St. Mary's Bay—seaweed and lobster shells—were Everett's finest accomplishment. He used them as a kind of public relations device: after the sale of a painting, Everett would grandly snap off a sweet pea and present it to a lady customer.

Everett and Maud did not do what people nowadays call shopping. Everett had a large garden, grew his own potatoes and picked up fruit from the farmers on his route, bartering fish for produce. Staples were purchased at Shortliffe's, the South End Grocery, or the Co-op in Conway, depending on Ev's whims. Maud's

MAUD LEWIS

wish list usually included ginger snaps and cigarettes. She loved to smoke Cameos, while Everett preferred the cheaper plug of chewing tobacco.

Everett bought few "perishable" items; cans of evaporated milk, beans, sardines, and corned beef were his preference. Fresh milk and butter came as gifts from Maud's friends and patrons, including Lloyd MacNeil, Ev's sometime employer, and President of the Digby County Agricultural Society. My father, Philip Woolaver, used to take elaborate gift boxes of cheeses, smoked bacon, honey and other delicacies he gathered up on his rambles as a country lawyer.

Everett was careful not to criticize Maud's shortcomings as a housekeeper, yet took pains to ensure that visitors knew he did the lion's share of the work. He came to terms with his failure to procure a housekeeper to cook his meals, tend the garden and bake the bread. But Maud's solution to the dilemma was, in fact,

Maud enjoyed painting sweet peas, tulips and roses. The return of songbirds to the apple blossoms was for Maud an event worth recording.

Untitled, undated
Oil on board
27.3 x 30 cm
Collection of Donna Cameron

Their evening meal featured
Everett's home-baked bread.

a better bargain than even Everett could have orchestrated. She resumed painting Christmas cards. When the weather was pleasant between May and October Maud accompanied Everett on his fish peddling route in the Model T. Maud was too shy to sell her creations, so Everett would show them to his customers, while she waited in the car. Everett handled the money. It soon became apparent that her contribution to their household was equal to, if not greater than, the housework that had been expected. After all, she brought in cash, something that Everett coveted, though, like his tools, he rarely put it to practical use.

This arrangement brought Maud a much-needed sense of worth. She enjoyed driving around with Everett in the Model T, and she derived great satisfaction from selling her cards, just as she had done in Yarmouth in earlier times. By 1939 though, their travels in the Model T came to an end. Everett took a job as night watchman at the Poor Farm, and Maud began selling paintings from their house. This routine lasted for the next three decades. While Maud painted, Everett tended the house, stove and garden, keeping a watchful eye on the Poor Farm. Together they greeted the tourists who came to buy Maud's paintings. This worked out well: Everett liked to peddle and haggle, and Maud loved to paint.

Facing page: "Cow and Car" depicts
Paul Lewis, the son of Maud's patron
Dr. Doug Lewis of Digby, N.S.

Cow and Car, undated
Oil on board
22.8 x 30.5 cm
Collection of the Woolaver family

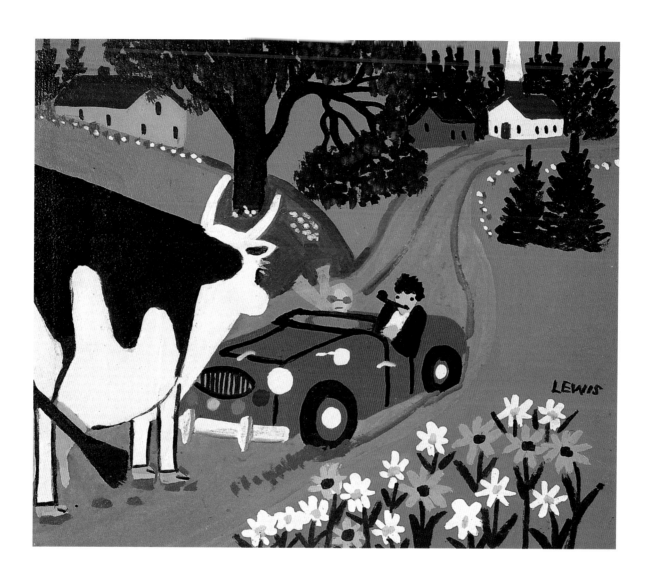

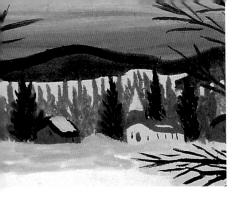

A Signature of Light and Colour

We know that Maud Lewis was painting in oils soon after her marriage in 1938 because surviving members of the family have commented that she had difficulty obtaining paints during the War. From 1940 to 1945, both house paints and artists' oils were difficult to come by. However, if a can of marine paint was found bobbing in the tide on Barton Beach, Everett fished it out and the paint made its way into one of Maud's paintings. Some of her work from the war years reflects this haphazard palette. An early painting of the Yarmouth Docks, perhaps the earliest of Maud's found to date, is painted in yellow and brown, unusual colours for a marine painting, but strong and charming nonetheless.

When Maud was well, and paints and boards were available, her output was two pictures a day. During the 1940s she painted more Christmas cards than boards, but later the balance was reversed, perhaps because the cards brought in coins, while for the boards, people paid in bills. Like most artists, she did not paint solely for money. She found joy and pleasure in composing colourful images that celebrated the happy memories of her childhood and the simple activities of rural life.

As her own style began to develop, she abandoned the childish pen-and-ink copying of humorous postcards, and began working in oils. Her clear and straightforward approach reminded many of the paintings of Grandma Moses, her contemporary in the United States. Maud's use of light and colour was, however, decidedly her own invention, free of direct influences. Like many painters, nature was her first subject; she was particularly attracted to sunsets. In one painting she shows remarkable daring by reflecting her sunset in a frozen lake: a family of deer admire a peaceful village while two sunsets brighten the horizon, one in the sky, the other on the ice. The scene is quite charming but the painting's attraction lies also in its subtle contradiction and unusual shades of colour. That the frozen lake, partly snow-covered, should reflect the sunset is a pure delight, but Maud takes the trick one step further. She

This Christmas card portrays blue-birds out of season.

Christmas Card, undated, Watercolour on paper
8.9 x 10.2 cm, Collection of the Woolaver family

Facing page: The Cape Island fishing boats were often painted in bright colours, providing, to the scavenging Everett, paints for Maud's seascapes.

Untitled, Circa 1963, Oil on particleboard
28.5 x 33.2 cm, Collection of Carole Regan

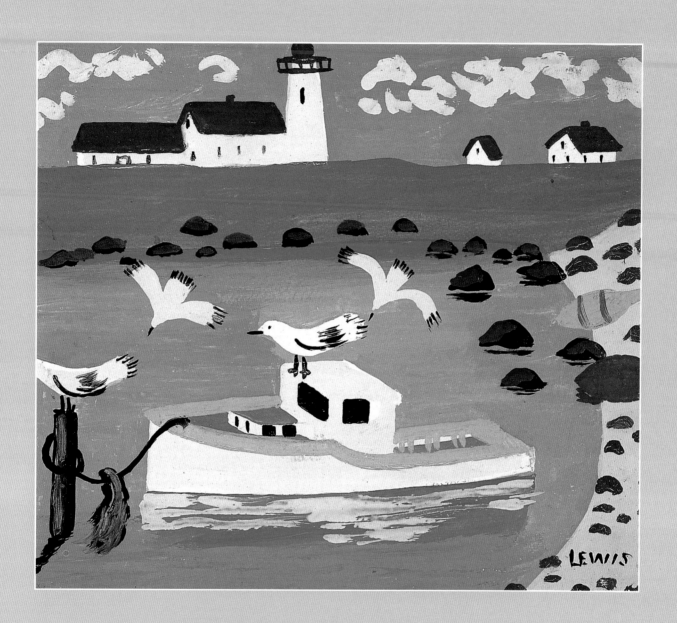

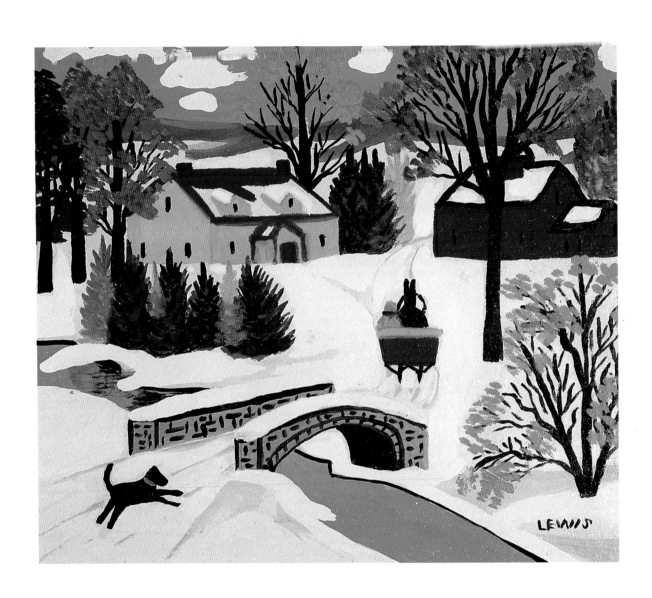

depicts two ranges of hills, one above the other, the lower covered in snow and the higher remarkably green. Although it seems unnatural that the higher range should receive no snowfall, while the lower is snowbound, the effect is beautiful.

As Maud's style developed through the 1940s, she became a frequent offender of nature's laws, almost always with success. She explained her displays of scarlet maple trees in great drifts of snow by saying that she had painted the first snowfall of the year. It seems more plausible that Maud simply liked to see the red and the yellow colours of the leaves against the blue and white of the snow. She painted them out of season because it pleased her. Maud preferred a leafy, colourful forest, and thus kept the leaves beyond their time, and the birds as well. It was the same spirit and flair that led her to paint blossoms on spruce trees.

Unquestionably, she knew what she was doing. When she painted three legs on a cow, or eyelashes on oxen, it was not an oversight. An extensive examination of her work confirms that these eccentricities are a consistent device she used to create pleasing and humorous works. Seen together, Maud's light-heartedness, detailed in an oxen's eyelashes, autumn leaves in snowdrifts, and cows blocking a road, reveals an intentional creation rather than unlettered mistakes. As Stephen Outhouse, a Digby folk carver, has commented, "If you see forty of them in a room, it does something to you."

Maud's intention was to entertain, to brighten people's lives with heart warming colours and subtle contradictions. One snowbound house, for example, has two window panes in the same room: one painted in yellow as though illuminated by light, the other dark blue, as though unlit. She repeated this incongruity in paintings throughout her career, making it a hallmark of her own unique style.

The inconsistent rendering of details are often touched with humour. One or two sleighs making their way up the hill would carry their drivers, a third might be empty. These little touches occur so frequently that they could almost substitute for her signature. One can almost hear Maud laughingly say: "Wait until they see this. Won't they smile!"

As well, Maud's use of shadows is often unconventional, even illogical. Sometimes her images contained no shadows, however bright the day, although occasionally she used pale blue to represent shadow or to trace the track of a sleigh in the snow. One object—a train or a sleigh—might cast a shadow, another would not. Hence the name, *A World Without Shadows* for the National Film Board film celebrating her life, and the play first performed in 1996 at King's Theatre, Annapolis Royal.

Facing page: **Maud consistently painted winter scenes with maples and oaks in fall foliage.**
Untitled, Circa 1960
Oil on board
30.5 x 35.6 cm
Collection of Mr. Bruce S. C. Oland

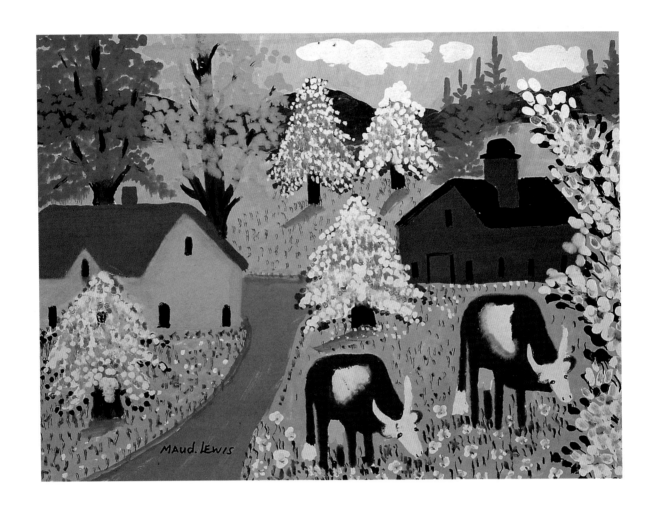

THE ILLUMINATED LIFE OF MAUD LEWIS

Light and shadow were such important aspects of her work that she painted few nocturnal scenes. She preferred to render the happy and the bright. One exception is *Midnight Moonlight*, which was reproduced in the Christmas 1975 issue of *Chatelaine* and features a house by a lake with a stone bridge over the outlet, and an appealing treatment of moonlight on the snow-clad spruce.

It is fortunate that these characteristics identify Maud's work with such authority because she often failed to include her signature. Two nearly identical paintings of snowbirds beneath a berry bush are a case in point: one is signed and the other is not. My father bought them both but did not bother to return the unsigned painting for its signature. There are also numerous unsigned Maud Lewis cake tins, beach rocks and Christmas cards. Maud was not inclined to finish a piece of art with her signature; often she had to be reminded. Her pleasure was in the creative act itself, not in the pride that she did it.

The "Paintings for Sale" sign, which hung on the front of the Lewis House, was the beacon of Maud's roadside trade, before the house itself served as an advertisement, and before the *Chatelaine* article and the CBC broadcast established her name. Maud had taken great care in painting the sign, embellishing it with her best-loved symbols: bluebirds, apple blossoms and butterflies. She had painfully inscribed the words, in capital letters—the I carried a surplus dot, with another dot centred in the middle of the O. It was one of her best works.

It was my father who had suggested the sign, and who later purchased it. He did not realize it too was unsigned until my mother noticed the omission when he brought it home. This time he took it back and coaxed Maud to paint her name on it. In the process, which took a good deal of time, Maud began to laugh and too much white paint was applied to the black background. The paintbrush contained too much turpentine and the thin paint spilled down the sign. Maud, a little irritated with my father's teasing, stopped laughing and sharply said, "Now look what you made me do!" The drip of paint is still there.

Maud generally painted her signature in black, brown or green—whatever dark colour she last used. The S at the end is a little larger than other letters, and a letter is likely to be rendered in capitals or lowercase without regard for its position. In most instances, the M and A of "MAud" are in capital letters, with the U and D in lower case. Occasionally, as on the sign, one finds a "Maud Lewis" with a dot over the capital I. The bottom stroke of the capital L often shows two or three strokes where she tried to smooth it out or make it level. Her tendency was to write uphill. The capital E often sat on the L, as if, like her right hand on her left, it needed a rest. There is a gap after the E and before the W. The S often took

A selection of Maud's signatures from the passing years.

Everett checking Maud's boards.

at least three strokes and leans forward as if it might fall over. Obviously Maud had the most trouble with the letter S.

Around 1940, Maud began to sign her cards and boards "LEWIS," with or without a dot over the I. Another characteristic of her signature at this time is that the word LEWIS is generally curved, as though traced around the edge of a twenty-five-cent piece. She rarely signed a painting "MAUDE," with an E, although some early Christmas cards are an exception, featuring the E in ornate script. Generally, though, Maud omitted the E, and letters she received from friends show her name spelled without the E.

In the 1950s, as Maud's reputation spread beyond Digby County, she began to sign her paintings "MAUD LEWIS." At the same time, she stopped painting Christmas cards because she found the detail difficult, "Too fiddly," as she said. At five for a quarter, they were more work and had less economic value than the paintings, for which she began to charge from two to five dollars. In the late 1960s, for some inexplicable reason, she added a period between her first and last name. Perhaps it represents her middle name, Kathleen.

Maud, it must be remembered, was an intelligent and lively person who learned to read and play the piano in her youth. Unlike her husband, she was not illiterate. Even late in life, with her hands and fingers twisted, she wrote a legible hand. Although she may have left a work unsigned from time to time, it wasn't because she wasn't able to do so; it was simply because she didn't think her name was important enough to bother about.

Examining the details of Maud's changing signature proves helpful when attempting to authenticate her paintings. Unfortunately, in the 1980s, Maud Lewis' work was faked: unscrupulous "artists" perceived it as being easy to copy. Their *modus operandi* was to secure some green-backed particle board, copy a couple of oxen out of *Christmas with the Rural Mail*, and sell the result for $200-plus at auction. In truth, most of the faked Maud Lewises were very bad renderings indeed, completely lacking in style and charm. In many copies the detail was more intricate than Maud's arthritic hands were capable of, and this alone gave them away. But there was another proof of an authentic Maud Lewis that no faker could duplicate. In the production of her work, Maud and Everett inadvertently provided a hidden signature. In the evenings, when supper was ready, Maud would hand her wet painting to Everett so that her bowl of chowder could be placed on the TV tray. The painting was set to dry. During the transfer, Maud's fingerprints and often Everett's thumbprints were impressed along the edge and generally halfway up the boards. It is these "signatures" that provide

indisputable evidence of a particular painting's authenticity. The Lewis House was always so cramped, and the circumstances in which she painted so wretched, that her early works, especially, not only carry traces of bristles and candle wax, but they are also fingerprinted!

Anyone viewing a film of Maud at the Public Archives of Nova Scotia will notice a detail in an image of the Poor Farm, which abutted the Lewis property. It is on the Poor Farm sign lettering, which indicated visiting hours. Obviously Maud had painted the sign. Capital letters are sprinkled throughout, in the most unlikely places; a period is stuck in the middle of a sentence; an S threatens to fall over.

Unfortunately, the sign had been discarded after the Poor Farm closed its doors, sometime in the 1950s. When I eventually found it in Marshalltown, during the research for this book, the wood was badly rotted, but a few flecks of black paint remained on the pieces to show where Maud had laboured to specify the hours when the poor might be visited by their friends and relatives.

A Primitive Technique

Apart from the lessons given by her mother, and exercises in penmanship at Yarmouth's Central Town School, Maud was self-taught. She painted almost exclusively from memory. Her paint supply was erratic and her surfaces eclectic. She is best known for oil paintings, most of which were executed on particleboard, masonite panels, cardboard, wallpaper, and Eaton's catalogue artboard. Both she and Everett referred to all these surfaces as "boards." A Maud Lewis painting on conventional artist's canvas, stretched and prepared for the purpose, would certainly be an interesting item. To date, none have surfaced. In 1996 the Art Gallery of Nova Scotia reviewed more than three hundred Maud Lewis paintings; not one was on canvas.

In addition to oil paintings, Maud produced a wide variety of works in other media. These included decorated household items, Christmas cards, scallop shells and beach rocks, and the Maud Lewis House itself. Her approach to every work was the same: she took whatever brush was within reach, dipped it in whatever paint was available, and dabbed it on whatever material was close at hand. There was an immediacy in the way she worked, as though the ideas were brimming up to the surface ready to be given expression at any given moment by her skillful hands.

Before gessoed masonite became her preferred surface, and professional artists' oils her colours, Maud did a great deal of drawing and sketching. Her sketch pads, in the form of "linen" notepads, used for letter writing, have survived. She also used rough, unbleached paper for greeting cards before she was given premium card blanks from Wallis Print. Happily, a large number of her Christmas cards are now found in private collections. These early works are mostly water-colours, delicately drawn and coloured, with much finer detail than usually appears in her oils.

Decorated household items that have survived include pots and pans, spruce shingles, the front door (both sides) and the storm door, a window pane, the wooden stairs leading to the loft, and the wallpaper. If it didn't move, there is a good chance that Maud painted it. The potential value of these items was recognized in Maud's lifetime, but after her death, collectors went to great lengths to acquire them. On one such occasion, a collector arrived at the house with two pretty girls who assisted him to procure an image painted on an interior wall by

Facing page: Maud did not make great use of shadow to lend definition to her paintings. At most, the shadow of a tree or the track of a sleigh might be represented by a pale blue line.

Untitled, 1965
Oil on particleboard
29.2 x 34.3 cm
Collection of Bob and Marion Brooks

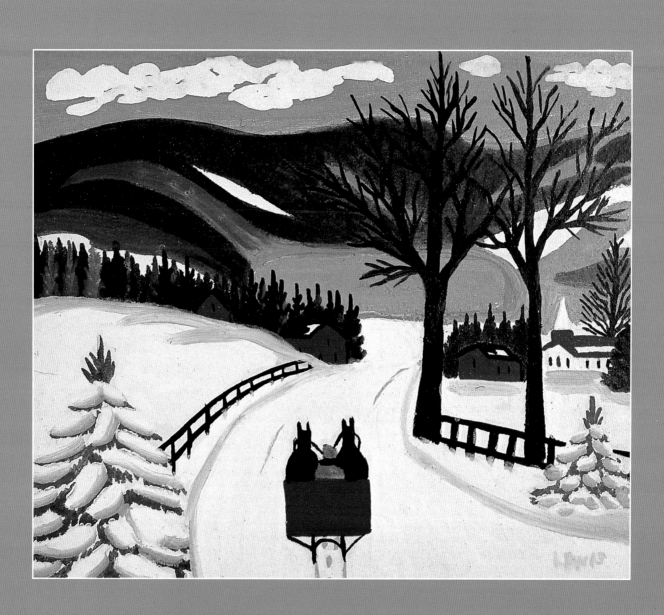

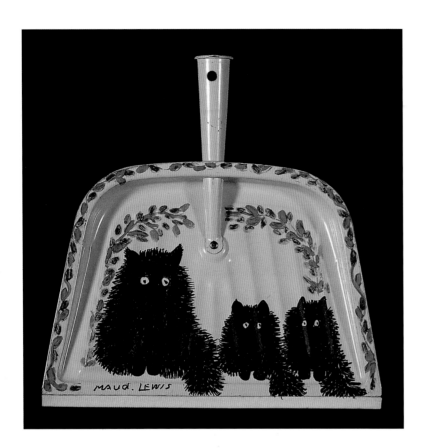

Once decorated, a Maud Lewis household item was rarely used for its original purpose.

Untitled, 1967
Oil on metal dustpan
21.2 x 30 cm •
Collection of Ruth Rousseau

flattering Everett. Unhappily, the painted flowers that once decorated Maud's stove now lie in the rust and dust accumulated on the floor shed in Waverley where the house was stored by the Province of Nova Scotia awaiting a permanent home with the Art Gallery of Nova Scotia. The stove itself appears unsalvageable and unrestorable.

One of the unusual items in Maud's collection is a baking tin, with a windmill painted inside. It is one of the rare examples of representation in Maud's work. The only windmill in Digby County was built on a hill in Bear River by a Dutchman named Geerligs. This is the only windmill that Maud would have seen, and we can safely assume that she was inspired by Geerlig's homage to Holland. The baking tin must have been close by when the image flashed into her mind.

The painted beach rocks and scallop shells are now rare items, which generally date from the 1950s. The big, round beach rocks, which could be used as door stoppers, were simply decorated with a flower or a butterfly. It was Everett's suggestion that she substitute them for the seasonal Christmas cards, probably because their surfaces were smooth and they were as plentiful as dandelions. But, being heavy and cumbersome, they were not very popular with Maud and she decorated them without her usual care. The scallop shells, on the other hand, were often signed "Lewis" and sported portraits of cats, usually black, and yellow butterflies. They too were plentiful. In the 1950s the world's largest scallop fleet sailed out of Digby. The shuckers tossed millions of shells overboard in the harbour and many of them washed up on the beaches. They were often used as ashtrays, which is likely how they first came to Maud's attention. They were about the same size as the Christmas cards, and their pristine mother-of-pearl interiors were inviting surfaces on which to paint.

Throughout the 1940s and 1950s, Maud's trade was largely in the cards and shells sold on Everett's fish peddling route, and in paintings for the roadside tourist traffic. Everett cut the boards for the paintings with his carpenter's saw, working in the shed behind the house. He scrounged scrap wood from the Poor

Farm dump, and picked up cardboard boxes from Shortliffe's Grocery in Digby. He never measured the panels but cut them unprecisely "by eye," making Maud's early paintings difficult to frame.

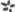 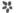 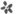

Every morning in the little house, after a cup of tea and a slice of bread, Everett would put the dirty dishes into a pot on the stove and bring Maud her paints. Seated in her chair by the window, her TV tray transformed from table to easel, she would pour a little turpentine, the cheapest type of thinner, into a Campbell's soup tin balanced on the unsteady tray. Sardine tins served as a palette. With her supplies and brushes about her, Maud would begin to paint. Everett

Maud painted the shells of the Digby scallops.

Scallop Shells, undated
Oil on shell
10.2 x 12.7 cm
Collection of the Woolaver family

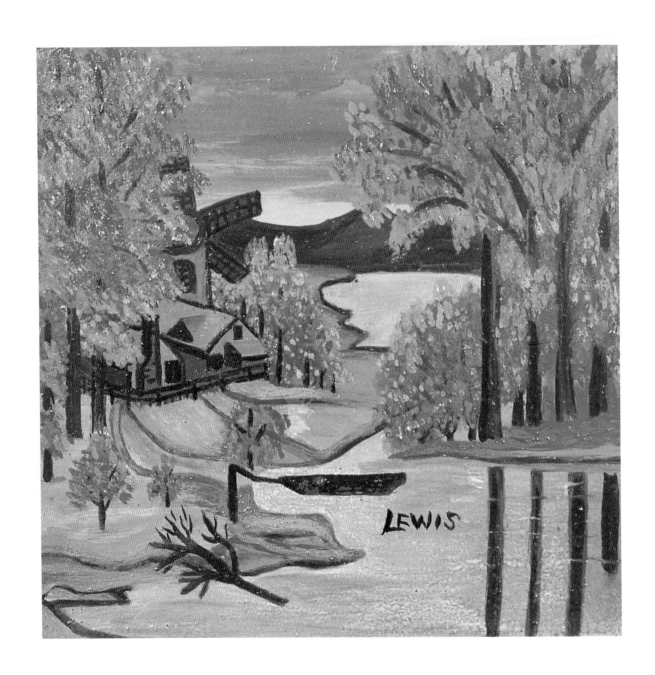

would go out to the woodshed to putter or, if it was a work day, to the Poor Farm.

Maud's chair was always in the window—which she had decorated with painted flowers—facing the highway. It was a cheerful, comfortable spot where she could watch the world come and go. In summer, the door to the Lewis house was always open, an invitation to passersby. There were other practical reasons: Maud's window provided limited light for painting. Perhaps of more importance, the paint fumes wafted outside instead of hovering in the limited space surrounding Maud.

One might well blame Maud's paints for her headaches. We know the death of Prairie artist William Kurelek has been attributed to lead in paint, and it now seems probable that much of van Gogh's psychological problems came from inhalation of toxic fumes, and the absorption of lead through his skin. In Maud's case, her headaches came quite frequently and this prevented her from painting at least one day out of seven. Photographs of Maud at work show smudges of paints on her hands. When she cleaned up at the end of the day her hands were saturated with paint and turpentine. She would habitually wipe her hands with newspaper that she kept within easy reach, then get up from her chair and throw the papers into the firebox of the stove. It is a wonder she did not set herself on fire.

The connection between paints and headaches, lead and ventilation, are particularly relevant in Maud's case because Everett scrounged much of her supplies. If someone was painting the bottom of a lobster boat, hauled up on the high tide at the wharf in Barton, Everett would be there when they finished (and sometimes sooner) to pick up the cans. With a little turpentine added to what remained in the bottom, Maud had a week's supply of red or green paint. In retrospect it seems serendipitous that the French Shore Acadians had such a fondness for painting their boats bright colours. On the other hand, these marine paints, and even the house paints of the day, contained a high proportion of lead. For the most part Maud used these paints at the outset of her career. Even with the door open, she spent a good deal of time breathing their fumes.

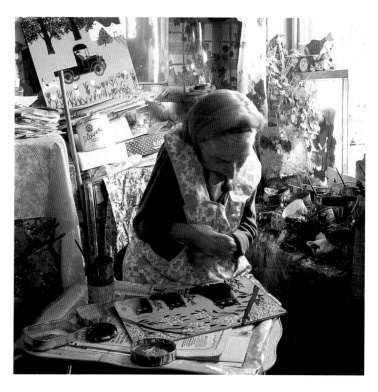

Maud worked in a restricted area and often in poor light. An oil lamp rested on the shelf in the corner. The TV tray held her paints, brushes, boards and candles.

Facing page: This cake tin shows the only windmill in Digby County, Geerligs' Windmill, still standing in Bear River.

The Windmil, undated
Oil on cake tin
22.8 x 22.8 cm
Collection of the Woolaver family

Although Maud brought her own brushes with her to Marshalltown, Everett later bought her a set of brushes and paints from an American tourist. Painters often came to sit on the wharves at Digby and Annapolis, and they often left their easels in Jack Rosenthal's antique shop in Digby at the end of the summer. Everett bragged that he obtained the paints and brushes for nearly nothing.

When Maud's work began to sell, she needed a more regular supply of paints than Everett's scrounging could produce. Fortunately, the source was not far away. Clara Harrington, widow of Anthony Harrington, a timber baron and lumber yard operator in Digby in the years during and after the Second World War, recalls how Everett came to bargain for unsold quarts of house and marine paint shortly after Harrington acquired the business. Anthony, a kindly man, gave him the unsold stock, a can or two at a time. Harrington was also the source of Maud's little tubes of tinting colour, called "Tints All" that she could thin with turpentine and use as regular paint.

Much later, when her work was sought by collectors and produced a steady stream of cash, Maud's brushes and colours came from May's Stationery Shop in Digby, from the Eaton's catalogue, and from Ontario painter John Kinnear. These were proper artists' colours, including Reeves oils from England. Her boards were later cut by Guy Harrington and Ralph MacIntyre and were perfectly square.

Maud's first brushes were cheap and inadequate, as her paintings attest. To clean her few brushes as seldom as possible, she often used the last brush at hand, usually a large one, for the signature. Consequently, the finer details in many of her signatures were crudely done and there are frequent blobs of paint. Her limited brushes led Maud to paint all the same-coloured details in turn before proceeding to the next. Nevertheless, they wore out quickly. Looking at Maud's paintings under magnification, one can see that her early paintings are littered with fine hairs that are embedded in the paste of the paint and difficult to see with the naked eye. They could be mistaken for air borne debris from an untidy one-room household, but it is clear that thick paints and cheap brushes caused the shredding. In one picture of horse teams, the black harness is decorated with little dabs of gold paint, representing brass on leather. A small bristle is stuck under the dab of gold and emerges on both sides, rather like a cat's whisker. Solidly lodged in the pigment, it looks as if the horse has a moustache on his nose.

In addition to bristles, little bits of wax speckle Maud's paintings. Everett refused to have their house wired for electricity, so if Maud wanted to paint after dark she could choose either an oil lamp or a candle. An oil lamp on

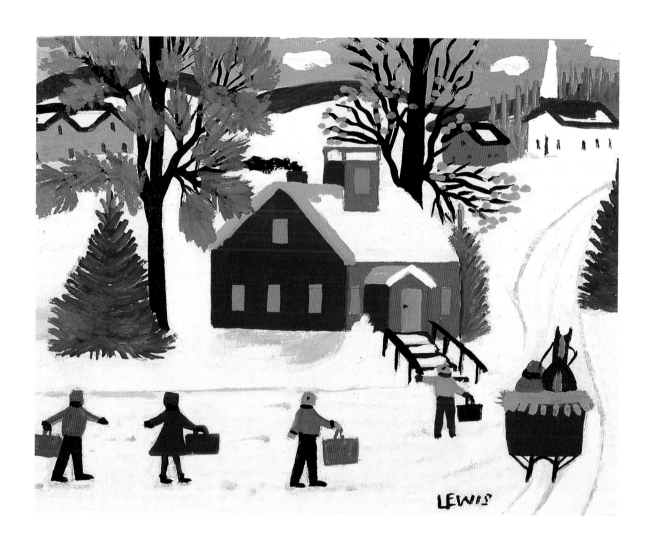

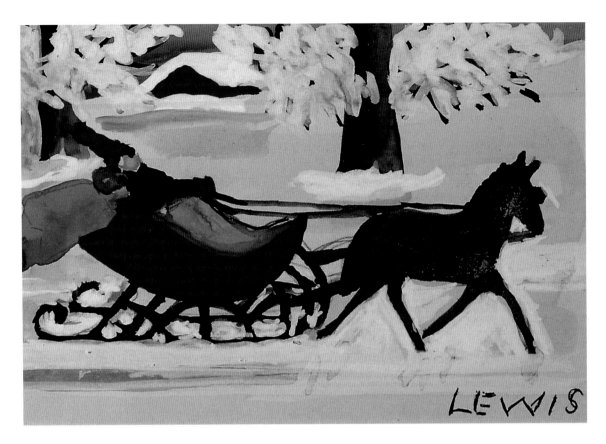

Maud's Christmas cards of the
1950s were often painted on
blanks supplied by Edith Wallis
of the *Digby Courier.*

Untitled, undated
Watercolour on paper
10.3 x 15.4 cm
Collection of William and Barbara March

Maud's unsteady TV tray would have been far too dangerous a contraption. A candle was safer.

Maud repeated the same scenes, the same designs, and when available, the same colours in her work. These were scenes from her memory, repeating like a favourite song. Collectors of her work have been surprised to discover copies of paintings similar to their own.

Maud often began a painting with a pencil sketch on the untreated white or cream surface of the particleboard known as "green board." She did not herself prepare the surface with gesso or paint. Typically, close examination of any Maud Lewis painting will reveal the pencil outline of the main figures in the painting. Large areas of colour—a ship's sails, the water, the horses' coats, and the logs on the sled—were then coloured in, one colour at a time. Small decorative details—brass decorations to a horse's black harness, the white snow on the limbs of the evergreens—were painted last, on top of the main colours, and often before the first layer was dry. This sometimes gave rise to interesting effects, particularly when a gold or silver metallic paint was placed on top of marine or house paint. The metallic paints tended to shatter and disperse into

spangles. This effect, unintentional, and most likely a source of irritation to Maud, was quite pleasing.

Maud painted her horses and oxen in decorative harness, even when ostensibly at work. She painted them as if she were actually harnessing them, following the sequence that the teamster would have used. After she had positioned the oxen, generally brown, on her board, she overlaid the black lines of the leather straps, then added a yoke, generally red. The vivid memories of a harness maker's daughter served her well. She knew the difference between the American neck yoke and the Canadian head yoke, and that the brass trim and the ox bells were the final touches to a well turned out team. In painting these details she maintained contact with her childhood, a time of happiness, joy and security. This cheerful nostalgia is an outstanding characteristic of her work.

Maud began at the top of the panel when painting landscapes—a hill against the sky, for example. Over this, the trees took shape, sometimes blending slightly with the hills and sky if these were still wet when the trees were added. Next, near the bottom, the figures of animals or children were applied. Finally Maud would colour in the empty spaces. She represented snow by leaving the unpainted surface of the board white, but the green grass in a summer painting was always a solidly coloured green.

Last touches might include accents of colour and shadings to the bold blocks of colour. A shade or shadow beneath a tree or bush, particularly in a winter scene, was generally painted in light blue, the same colour she used for sky. A dark spruce or fir might have a second layer of pale green imposed on the dark green boughs, or a light layer of white snow. The dark brown of the tree trunk would be accented with a lighter brown. Maud did not mix these colours, and if she were lacking an appropriate colour for the accents she did not hesitate to substitute an inappropriate one.

When the painting, three or four hours of work, was complete, Everett would put it up on the warming oven of the stove to dry, particularly on a winter's day. In summer, it might be left in the window, as proof of the sign, "Paintings for Sale." The works were never put outside to dry because of the dust from the road. Such was the demand that her paintings were often sold wet.

When Maud was working, her tiny, quick strokes at the panel resembled a sparrow pecking at a bit of bread. As she painted each scene many times, she didn't need to contemplate. She worked straight through until it was finished, not stopping for tea. Holding the brush with her right hand, as one holds a pen, her left wrist positioned under her right arm, propping it up and giving it

support, she bent over the panel, squinting at it, hunchbacked, intent. She was so small the large brush came up past her ear. She rocked slightly back and forth, and she did not smile until it was finished. One would be surprised at the speed with which she worked and how quickly she could complete a picture. Maud worked as efficiently as a farm-wife rolling and cutting a pie crust.

That Maud's technique was untutored is part of her success. That her materials were primitive was complementary to her style. She never met another artist, with the exception of Fred Trask, who visited her house in later years. She corresponded with Ontario artist John Kinnear but he did not attempt to influence her art. The arrival of fame, in the sense that she was able to obtain artists' oils, might now be regretted. These later paintings have a less engaging charm, especially those painted on Eaton's artboard with the Reeves colours.

Maud's most primitive and varied work came early in her career, in the water-colour Christmas cards and paintings on particleboard. Her later work became standardized as customers demanded the paintings of oxen and cats they saw in the kitchens of their friends. Success is more pleasant than failure, but it did have a less than positive effect on Maud's work. She felt obliged to paint what her customers requested, and eventually her day's work came to resemble an assembly line. In 1968, when her health seriously declined, Maud began using cut-outs of cardboard and paper to trace the main figures in her paintings, and Everett often filled in the colours as best he could. This use of cut-outs explains why the farmers and oxen in many of her latest paintings are exactly the same size, and are outlined in graphite pencil. She was no longer painting her own inspired fantasies but filling orders for a growing market.

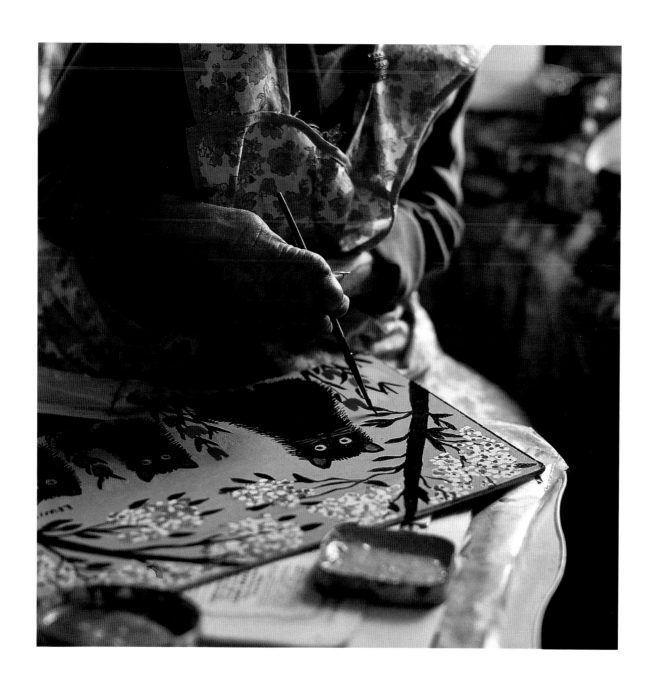

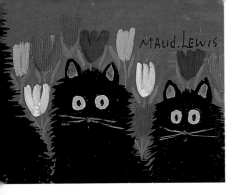

Two Artists, Two Worlds

In 1967 things were going well for Maud Lewis: she was at the height of her fame. Under the tight-fisted regime of Everett, the couple lived such a frugal lifestyle that they were free of debt and Everett had amassed a healthy bank account. Articles published about Maud's work brought orders, cash enclosed, to the mailbox on Highway No. 1, and her admirers brought her paints and boards. She could scarcely keep up with the demand.

It was at this point that Maud's work began to be compared with that of Grandma Moses, the celebrated American folk-artist. A 1967 magazine cover

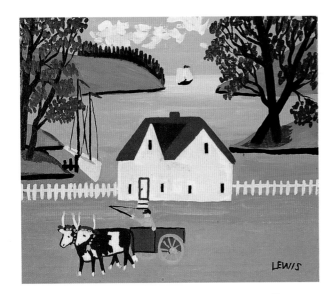

Maud's customers requested certain scenes and Maud painted them many times. This seascape of Digby Gut was very popular.

Digby Harbour, undated
Oil on board
22.8 x 30.5 cm
Collection of the Woolaver family

Facing page: Maud would often paint the same scene and simply change the season.

Oxen and Logging Wagon, undated
Oil on particleboard
26 x 35.8 cm
Collection of the Art Gallery of Nova Scotia; gift of M. Louise Donahoe

described Maud as "The Maritimes' Grandma Moses," and carried the headline "Frail Woman With a Bold Brush." This comparison was to continue long after both Maud Lewis and Grandma Moses had passed away. As recently as 1987, an article in *Reader's Digest* repeated this theme and it served to illustrate how high Maud's star had risen. However it also gave rise to several misleading assumptions.

In the broadest sense both Maud Dowley Lewis and Anna Mary Robertson Moses were folk artists, self-taught and unassuming; but there are far more differences in their lives and work than similarities. To begin with, Moses lived a comfortable life in the countryside, first in the American South and later in New England. Her life was industrious and full of children and grandchildren and her strong will ruled the roost in her household. She enjoyed good health and was a participant in all the events she painted. Furthermore, Grandma Moses discovered the tranquillity of painting at the age of sixty-seven, after a life packed with entrepreneurial adventure. She lived more than a century and was productive until the end. More than fifteen hundred of her paintings have been documented.

The narrative of Maud Lewis contains few of the elements that make Grandma Moses' life so appealing. Maud died at sixty-seven, the age at which Moses began to paint. Far from prosperous, much of Maud's life was one of deprivation. When her parents died, Maud came to depend first upon the kindness of her aunt, and later on the support of her husband. She was in need of security and a permanent home when she married Everett Lewis.

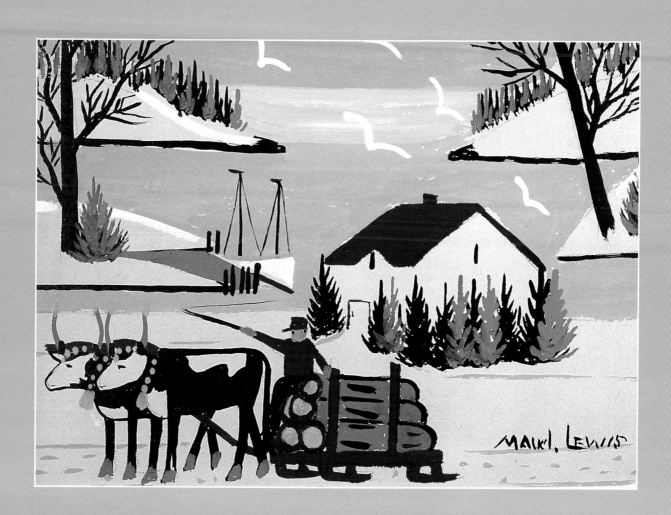

We know that Maud began painting as a child, as a means of supplementing the family income. While Everett had secret stashes of cash, his wife lived her life as though she were in danger of becoming an inmate of the neighbouring Poor Farm. When Maud Lewis painted a delightful country scene, it was not because she had been a full participant in such simple pleasure, but because she had been shut out of such enjoyment by her illnesses and deformities. Maud Lewis' paintings came from an inner desire for joy and a longing for a life she had experienced only fleetingly in childhood.

Both Maud Lewis and Grandma Moses painted for a market. Moses' first works were sold in Old Thomas' Drug Store in Hoosick Falls, near her New England

home at Eagle Bridge. Maud's adult efforts were sold at roadside to the tourist trade. For Grandma Moses, her sales were a surprise and a welcome surplus to her good fortune. For Maud they became a major source of household cash and a necessity.

Thematically, Grandma Moses and Maud Lewis share a good deal. They took their subjects from the rural life they knew, and there was little difference between New England and Nova Scotia in the first decades of the twentieth century. There were small farms and coastal fishing on the one hand, and the wide world of marine trade on the other. The conveyances were schooners, wagons and sleighs, and the little horse-drawn carriages known as buggies, shays and buckboards, all soon to be swept away by the steamship, the locomotive and the automobile. Stylistically, however, Grandma Moses and Maud Lewis were a world apart. Moses filled her panels with landscapes crowded with people. If they included sheep, she called them "lambscapes." Moses typically included two or three valleys in each painting; each hill and valley displaying the people and their occupations. She put her business experience to good use in detailing a complete inventory of the industry of the countryside. This gave her work a breadth and scope that Maud's did not attempt.

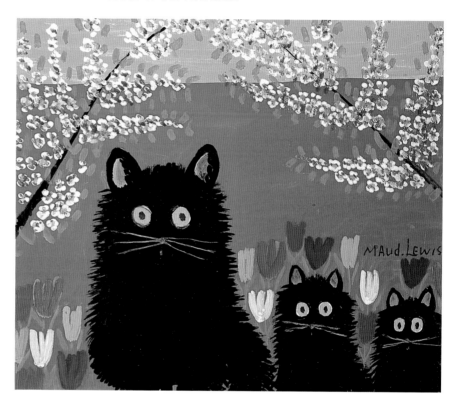

Maud liked to paint both black and white cats, preferably in a happy group and surrounded by blossoms and flowers.

3 Black Cats, Circa 1966
Oil on particleboard
30 x 35.4 cm
Collection of Robert and Betty Flinn

Although both artists were honoured by receiving orders for their work from the White House, there is no record or suggestion they were aware of each other. Grandma Moses came to the attention of the White House under the administration of President Truman. She visited the President who played the piano at her request, while "Bess" Truman poured tea. When she returned home to Eagle Bridge her conversations were recorded and broadcast on radio.

Maud Lewis was brought to the attention of President Nixon by White House aide John Whitaker who owned a considerable number of Maud Lewises.

THE ILLUMINATED LIFE OF MAUD LEWIS

It is the intimacy of these paintings that distinguish the work of Maud Lewis from her contemporary Grandma Moses of the United States.

Maud and Ev, undated
Oil on board
22.8 x 30.5 cm
Collection of the Woolaver family

Previous spread:

Left: This marine painting is representative of Maud's work. It shows the mudflats and low tides common to Yarmouth and Digby counties, as well as the common types of fishing vessels.

Untitled, Circa 1942
Oil on particleboard
21.8 x 29.5 cm
Collection of Mary Sadleir

Right: This portrait of Nova Scotia's sailing ambassador, the schooner *Bluenose,* is atypical of Maud's work and a special request. She did not usually identify her ships and boats.

Untitled, undated
Oil on board
29 x 42.6 cm
Collection of Dr. Douglas E. Lewis

Whitaker enquired if Maud could make two of her paintings available. Maud replied with what must rank as among the most simple and sensible of letters ever written to the White House. She stated that if the White House would send her the money, she would be glad to forward the paintings. We know the transaction was completed as President Nixon later signed a card of condolence to Everett upon Maud's death.

Maud's reaction to her fans in the White House illustrated her lack of appreciation of the role fame can play in an artist's career. Maud was not a careerist, and she valued those friends, like Ontario painter John Kinnear who corresponded with her regularly, far more than an order from a premier or president.

Grandma Moses was a successful farmer, at one point running a two-hundred-and-forty-hectare dairy farm. She began with a butter churn and ended with a thriving business. She enjoyed an affectionate marriage, but retained a flinty independence, giving her children the Robertson family name. When her daughters married, Mrs. Moses sewed their wedding dresses and regarded them as her greatest accomplishment, far more important than the paintings she sold in the Hoosick Falls drug store.

This active, capable woman started out with simple make-do materials for painting but eventually came to shun anything second-rate; she bought fine high-quality brushes for her work. Remarkably, before starting a painting she first bought the frame on the principle that one would not buy a cow without having a place to put it. By comparison, Maud's life and painting are indeed primitive. For materials, Maud used what came to hand. Her marriage to Everett ensured that with the exception of charitable gifts, everything in her life would be second-rate.

Grandma Moses' life was expansive and extroverted, and her paintings are a record of everything in which she excelled; she was a purposeful and successful entrepreneur and as soon as she felt her work was saleable, she began to sell it.

This painting was published in the children's book *Christmas With the Rural Mail*, the first in Canada to feature folk art as illustration.

Untitled, Circa 1959
Oil on particleboard
29 x 34 cm
Collection of Mary J. Dolan

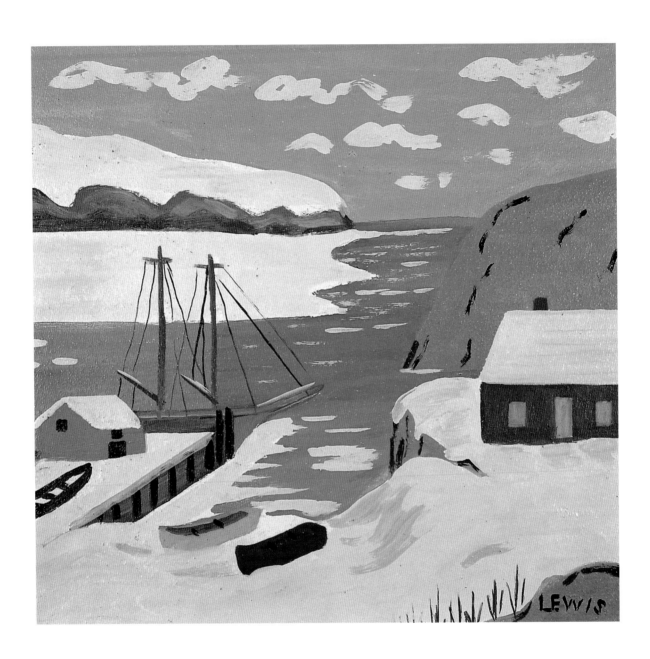

THE ILLUMINATED LIFE OF MAUD LEWIS

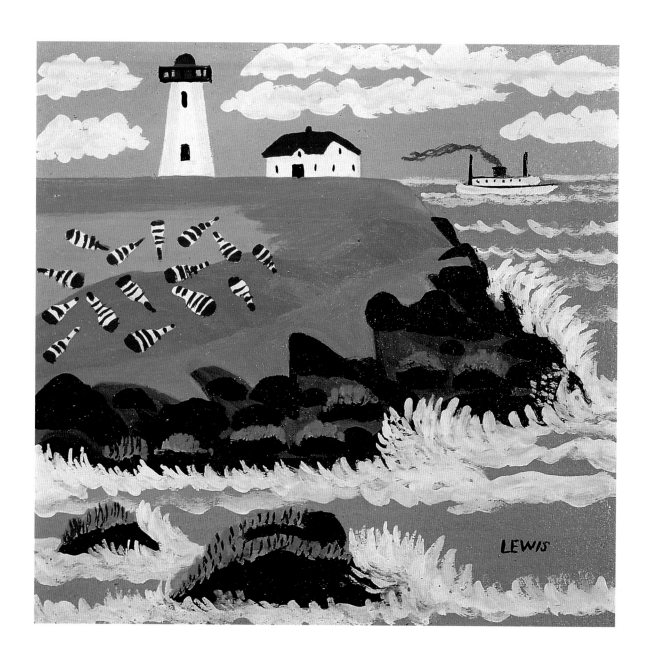

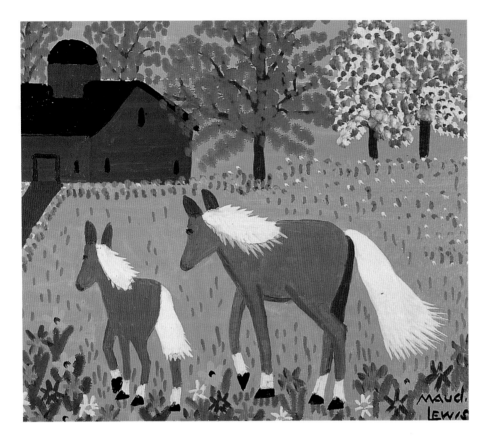

Maud did not portray human subjects in detail as she has rendered this mare and colt.

Untitled, undated
Oil on board, 29.2 x 34.4 cm,
Collection of Dr. Douglas E. Lewis

Previous spread:

Left: This winter and marine scene is unusual because it includes no human or animal figures, and no blossoms, birds or flowers.

Untitled, undated, Oil on particleboard
28.5 x 31.2 cm, Private Collection

Right: Herein the spritely waves are the marine equivalent of Maud's flowers and blossoms. Like many of her paintings, the scene is based on an actual location, this one at Point Prim, Digby County.

Untitled, undated, Oil on particleboard
29.8 x 30.5 cm, Private Collection

It was very much a matter of keeping active and earning her keep. She said that if she hadn't begun painting, she would have raised chickens.

In contrast, the life of Maud Lewis was restricted and interior. She was shy, almost reclusive, and her painting exudes the joy that she must have felt in overcoming the odds. At times this was simply being able to survive. Her inner stamina allowed her to accept whatever came her way with patience: the death of her parents, the abandonment of her home, the separation from her child, her disfigurement and pain, and the imposed impoverishment of life with Everett. Unlike those of Moses, Maud's paintings seldom contain a crowd; there was never a crowd around her. Instead her subjects were patient oxen and loyal cats—animals whose virtues were constant. Everyone who met Maud was touched by her smile, her innocence and her determination. Through her painting Maud made, quite unselfconsciously, some very good friends—Judge Woolaver, the MacNeils, Doctor MacDonald, to name a few—but most of all she attracted everyone who stopped by with a quiet charm, and left them with the impression that within her world, all was well.

While Grandma Moses was interested in scope, Maud Lewis was compelled to intimacy. When we see a Grandma Moses "lambscape" the flock is portrayed as part of the harvest. When we see a Maud Lewis kitten, we want to give it a name. Perhaps there was little to be gained but fame by calling Maud Lewis "Canada's Grandma Moses." The lives they spent and the pictures they painted argue against the continued use of the term.

Maud Lewis cared so little for fame that when Ontario painter John Kinnear suggested she participate in Canada's celebration of its one hundredth birthday, she quietly excused herself. Her laconic reply was stamped with a modest

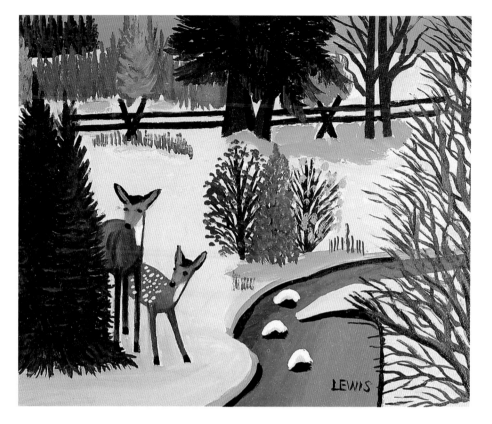

This portrait of a doe and yearling fawn never had a human equivalent in her work.

Untitled, Circa 1960
Oil on board
30.5 x 35.6 cm
Collection of Mr. Bruce S. C. Oland

estimation of her art. "No, I'm not putting anything in Expo '67. I haven't the time to paint anything for it."

By 1967, Maud's name had spread well beyond Digby County. She was far behind in filling the orders that arrived in the aftermath of the *Star Weekly* article and the CBC *Telescope* broadcast. She worried about her commitments and was inclined to return the money until she had finished a requested painting. For Maud, pleasing her customers was more important than Expo '67. She probably never gave it another thought.

Despite her growing reputation Maud did not think of her paintings as art, nor did she see herself as an artist. As Doris McCoy commented in the *Atlantic Advocate* in 1967, "Rather she regards them with the same feeling an average housewife would have about an attractive apron she'd completed for the fall fair."

The mailbox was lettered Everett Lewis, although the bulk of the mail was for Maud.

The End of Maud's Things

Maud Lewis' fragile health went into decline in 1968, after she fell and broke her hip. As she had never been physically active, there was little possibility she might fully recover. Apart from her infirmities, she had suffered for decades from the paint fumes and wood smoke. Her lungs were not strong. As Everett later conjectured, she loved to smoke cigarettes, and she was not strong enough to "throw off the poison." Dr. M. R. MacDonald of Halifax remembers his wife and Maud chatting and smoking cigarettes during their visits. "As soon as the ladies lit up," said Dr. MacDonald, "I got out."

After she came home from Digby General Hospital, Wendy Franklin of the Victorian Order of Nurse cared for Maud at home. Everett did what he could to make her comfortable but the lack of amenities in the little house must have made it difficult. One day, when Maud wanted to paint in the trailer, he trucked her out in the wheelbarrow. Before long she was back in the hospital with multiple complications, still concerned with unfilled commissions. Her last works of art were made possible by her good friend Kaye MacNeil, who brought a set of felt-tipped pens with which Maud made Christmas cards for the nurses. She contracted pneumonia while hospitalized and died on Thursday, July 30, 1970.

Maud was buried in a child's coffin. A graveside service was held at the North Range Cemetery at 3:30 p.m. the following Monday with Reverend Myrtle Ingersoll of the Barton Baptist Church presiding. It was a graveside service because Everett would not enter a church. Maud's friends Kaye and Lloyd MacNeil, together with all the dignitaries in Digby County, including members of the Legislature and of Parliament, attended the funeral. Maud was both famous and loved: her burial was the best attended in decades.

Reverend Ingersoll chose passages from the Twenty-Third Psalm, "The Lord is My Shepherd," and Psalm Ninety, "For a thousand years in thy sight are but as yesterday when it is past, and as a Watch in the Night." In her eulogy she quoted from Psalm Fifty-One, "Restore unto me the Joy of thy Salvation; And uphold me with thy free Spirit."

These words, spoken over Maud's grave, were a fitting tribute to someone who had shared her inspired gifts of colour and imagery. Everett, who had been drinking, was a disturbance at the service, and Reverend Ingersoll cautioned "the husband" to listen to the "Voice of the Eternal."

Maud was shy with many of her visitors, withdrawing into a protective silence and letting Everett play the host.

Facing page: The white dog with the black spot is a common Maud Lewis subject, while the brother and sister could only be looked upon as a late-in-life recollection of her happy childhood.

Untitled, undated
Oil on particleboard
21.5 x 29.5 cm
Collection of Catherine J. Wilkins

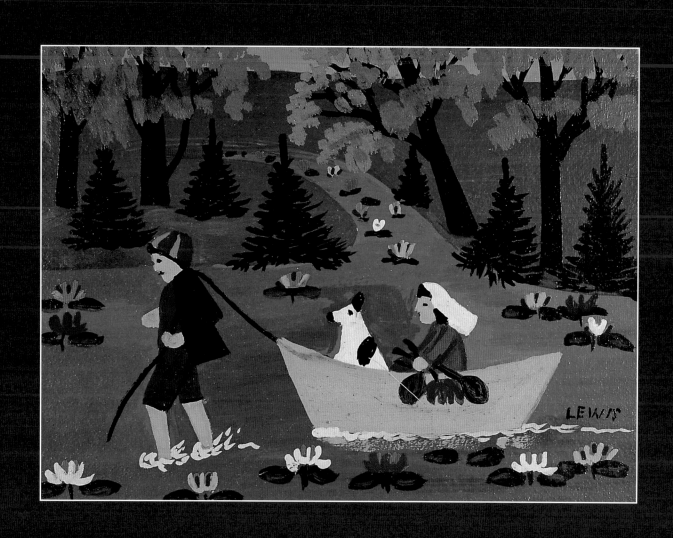

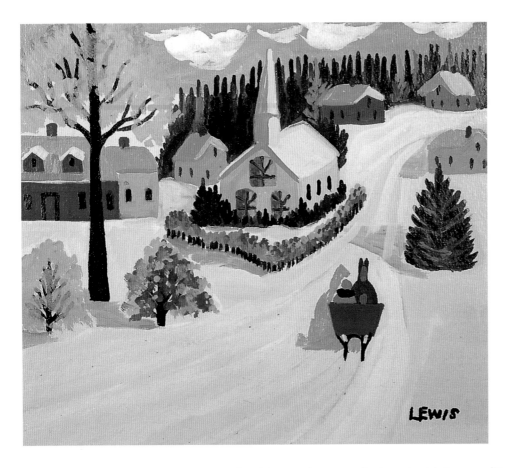

In Maud's paintings of churches, illuminated windows indicate a service in progress. While married to Everett she did not attend church, but she painted this one many times.

Sleigh and Village Scene, undated
Oil on particleboard
26.3 x 30.1 cm
Collection of Nova Scotia Department
of Education and Culture

For a year previous to her death, Maud had been unable to paint her one or two paintings a day. She had difficulty completing two or three in a week. Apart from Everett's monthly $81 Old Age Pension, Maud's painting had become their only source of revenue. Everett, not wanting to see a potential buyer leave empty handed, had begun turning out his own paintings, with which he would proposition anyone who stopped by. He pocketed the money, at times burying it in jars in the yard. Although most homeowners in Digby County had replaced their outhouses with indoor plumbing and were enjoying electricity, conditions in Maud and Everett's little house had not changed in decades. When neighbours began throwing out their iceboxes, Maud asked Everett to get one, but he refused. Ice had to be paid for.

Collectors Bill Ferguson and Clair Stenning had tried making and selling prints of Maud's work but apparently they did not succeed. In a letter to John Kinnear, Maud complained that she had not received any money from the prints.

If ever Maud regretted the loss of any comforts she had enjoyed during her life in Yarmouth, it was music she missed the most. Everett would not permit her to go to church, although there were wonderful choirs in Jordantown and Digby. She still had the phonograph from her father's house, but the spring was broken, and Everett made no attempt to fix it. A radio or television, now common forms of enjoyment, was out of the question. By the time Maud died, both my father and Dr. Doug Lewis, Maud's doctor (but no relation), had gathered a fine collection of Maud's paintings. Both collectors greatly admired her talent and their friendship was a buffer against Everett's miserliness. My father knew a lot of old country tunes and hymns and he would sing a verse and ask Maud if she

knew it. Eventually, she would break into laughter, but she would not sing. Like many people of her generation, she wore dentures, which, in her case, were discoloured and fitted badly. When she did laugh at his teasing, she would cover her mouth and turn away. My father took Maud a battery-operated Canadian Tire radio. Everett used to take the batteries out of the radio and wrap them up in wax paper, to save the charge. Perhaps nothing is so evocative of the dynamics of their marriage as Maud's love and Everett's rationing of music.

In 1996, when the Art Gallery of Nova Scotia inventoried Maud's personal effects, the radio was not among them. Its leather case was there, but, like many of the personal items Maud had cherished, her radio was missing. As both Barry Jennings, the first owner of the house after Everett, and Stephen Outhouse of the Maud Lewis Painted House Society had been conscientious caretakers, the missing items proved a mystery. It was solved when Major and Mrs. Kriisk of Greenwood, Nova Scotia, called me that same year to say they had the flat-iron Maud had used to iron her clothes. They had bought the flat-iron for $1 from

A buggy pulled by a single black horse might well have illustrated the country doctor on his rounds.

Untitled, Circa 1966
Oil on particleboard
22.8 x 30.7 cm
Collection of Eve Wickwire

Facing page: **The dark windows of this country church and the night sky indicate a night visit.**

Untitled, undated
Oil on particleboard
23 x 30.5 cm
Private collection

Everett but refused his offer of other items. The purchaser of Maud's radio is not known. Perhaps it will surface. Other items Everett sold included the sympathy cards he received after Maud's death; he tossed them into an empty chocolate box and sold them for $1. Among them was a sympathy card from President Nixon bearing the Presidential Seal. Being illiterate, Everett could not read the inscription:

> *"With my deepest sympathy and prayers."*
> *(Signed) Richard Nixon.*

It is a rare widower who sells his own sympathy cards.

To Everett, Maud had meant companionship, and, in the end, money, but she had never meant family. For years he had chafed at playing second fiddle in his own house. After her death, Everett did not erect a gravestone to Maud's memory with her name and dates of birth and death. Instead, he had Maud's name engraved at the bottom of the Lewis family stone, which honours Everett's parents. He had Maud's name cut as "Maud Dowley." Until 1996, when a cairn was erected at the Lewis property in Marshalltown, no memorial stood in Digby County to its most widely admired artist and best-loved citizen.

Everett Without Maud

Most country folk would have nailed the horseshoe upturned over the door to "hold in" good luck. Everett is dragging firewood by toboggan to their house.

The Lewises had been married for thirty-two years when Maud passed away. With the exception of one trip to Halifax, and the early excursions to sell Christmas cards, Maud spent most of those years sitting in the corner by the window, painting and watching the world go by.

She did not garden or grow flowers; she did not attend church, let alone church socials. When the truck came down from Jordantown for Christmas carollers no one thought of stopping at the little house. Maud never went to meet and greet friends at the train station or bus depot. She never once ate a meal in a restaurant, nor purchased a store-bought dress. Social pleasures of this kind were not hers, for the most part, prior to her marriage, and there ceased to be any with rare exception after.

Unlike other folk artists, such as Grandma Moses in America and Helen Bradley in England, Maud Lewis did not, for the most part, paint people. They were not central to her imagery. However, amid all the animals and birds, flowers and sunsets, there is one human figure who appears again and again. He is a tall thin man in country clothing, often wearing a red hat with ear flaps, a red sweater with black trim and knitted mittens. This, without doubt, is Everett Lewis. Sometimes he appears in a checked lumberman's jacket. He is found driving great teams of lumbering oxen, harnessing the restive horses, hauling the logs to the mill, and accompanying Maud at the wheel of an old Model T Ford. If any further evidence were needed to confirm his identity, Bob Brooks' photographs taken in 1965 show Everett wearing the exact same outfits.

This figure appears in virtually every painting requiring a woodsman or driver to attend to the animals. These are happy paintings and confirm that, for Maud, Everett was a solid and benign presence in her life. He often represents the only human element within a country landscape, and his appearance in her paintings can only indicate she held him in high regard.

For all of Everett's faults, he was a true companion. Not only did he take care of the house, at least to his own standards, he kept the fire going, tended the garden, and prepared their meals at the end of the day. He may have been drunk occasionally, he frequently lied, and he exaggerated in order to put himself in a favourable light. Nevertheless, he made it possible for Maud to do what she loved best: paint as much as she wished as often as she could. He provided her

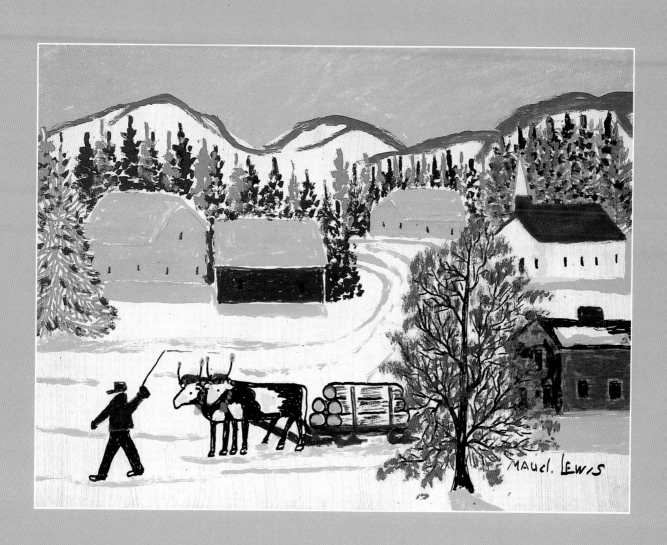

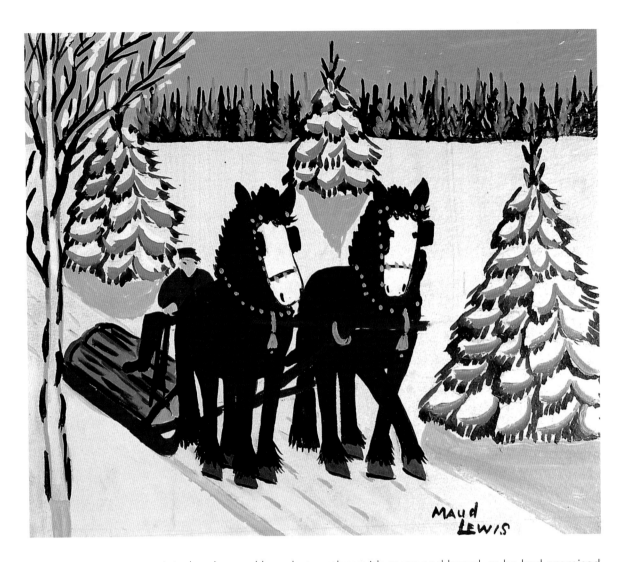

Maud Lewis was happy at her work and her work horses were happy at theirs; they prance with heads high, proud to pull a heavy load.

Untitled, undated
Oil on board
30.3 x 35.3 cm
Collection of Dr. Douglas E. Lewis

paints, brushes and boards, together with room and board, as he had promised. Many artists would have settled for this. Everett gave Maud security while retaining control over their finances; he exploited her work to serve his own obsession with money. This may not be a happy narrative, but there are worse in the history of art. The tall man in Maud's work is indeed Everett, so perhaps we can assume that Maud appreciated him, loved him and honoured him by awarding him a place of prominence.

Everett was seventy-seven when Maud passed away. He had lost all his teeth and was too cheap to buy a set of dentures. He wore glasses, but not in public. People remember him for his hilarious mispronunciations, such as the time he asked for "some of that good Tabados molassis," meaning Barbados molasses. Everett lived a further nine years in the little house after Maud's death, and his

personality did not improve; he was sometimes irascible and sometimes fawning, depending on the importance of the visitor. He professed poverty and continued peddling his own paintings, although he clearly did not need the money. His reputation as a miser was more difficult to overlook, particularly as Maud had suffered deprivation simply because Everett wouldn't spend their savings. He was, above all, a curmudgeon, a Silas Marner, who buried cash in his garden and under the floorboards of his house. Perhaps he was trying to compensate for the lack of security in his own childhood. What he eventually intended to do with the money is a mystery but he was willing to part with it in a time of crisis. When an ambulance came to take Maud to the hospital for the last time, he tried to bribe the driver with $50 to take her to "The Refinery" (another of his malapropisms), in Halifax, and not to the local hospital. The Infirmary in Halifax was considered by Ev to be a better hospital.

As the years went by Everett became more and more eccentric. He wore tattered dirty clothing that made him look like a ragged old raven, his coat flapping in the wind, his sunken face covered in stubble, his bright eyes suspiciously observing everything in view. He wore his lumberman's checked shirt buttoned up to the neck, winter and summer. Whenever he made a public nuisance of himself, someone would say, "If he don't watch out, he's goin' to git it." And get it he did. In 1979 a young man broke into the little house, hoping to steal Everett's cash box. Everett died in the struggle to save his money.

There were mixed feelings among his neighbours. Some were saddened to hear that the man they thought of as Maud Lewis' keeper in life had been murdered; others felt that he had brought it upon himself by being a miser and a loner.

The Survival of the House

After Everett died, the little house in Marshalltown became a point of contention in Maud Lewis' legacy. Everett Lewis had made it clear to many visitors, it was his house. He lived in it before Maud arrived and after she died. However, as she left her mark so visibly on the structure, it had become known as the Maud Lewis House. Everett's solution was to sell the door and repaint the house.

In other circumstances it would have been worth very little. Even the land was not worth much; adjacent land had been used for a pig farm and for growing strawberries. The outbuildings were shacks, without foundations, rotten at the sills, and covered in flapping tarpaper. Without heat in the winter and spring, and with the wind blowing through the crawlspace beneath the floor, the Maud Lewis House was destined to rot to the ground in a few seasons. Frozen in the winter, flooded in the spring, the boards and nails would spring and come apart, and a windy day in fall could strip half the shingles off the roof. However, this was no ordinary little country house. It had been transformed by Maud Lewis into a landmark known far afield, a sight that travellers told one another to look out for if they were ever in Digby County.

There was talk that it must be preserved. Not long after Everett's funeral, a group of citizens came together to form the Maude (sic) Lewis Painted House Society. The five founding directors who incorporated the society in March 1979 were the Reverend Isaac Butler, René Richard and his son Paul, and Maud's good friends, Kathleen (Kaye) and Lloyd MacNeil.

Then began a long and tangled story of attempts to preserve and restore the house. For the next five years René Richard, the president, worked diligently to raise funds to restore the Lewis house, but with little success. When funds were at their lowest, he borrowed $6,000 and loaned it to the Society. Unhappily, his efforts were not supported, and the society ended as the subject of controversy rather than preservation. Their problems began with the settling of Everett's estate. Most members of the Maude Lewis Painted House Society presumed that the heirs would donate the house to them on the assumption that the house was no longer a house but a work of art. They were disappointed when the heirs executed a deed to Barry Jennings, a distant relative of the Lewis family.

Facing page: Flowers were not a much requested subject by Maud's customers. She painted them for her own delight.

Tulips, undated
Oil on particleboard
23 x 30.5 cm
Private collection

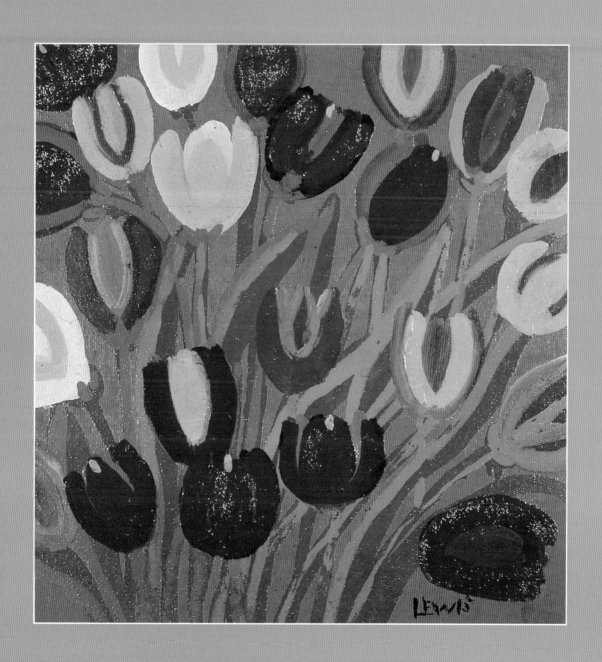

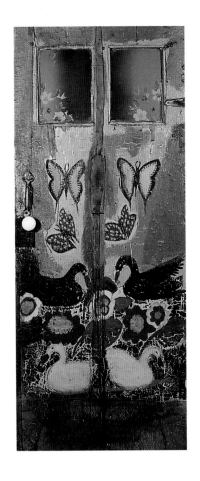

One immediate concern dictated immediate action. The little house, set apart from its neighbours, was vulnerable to vandals and treasure seekers. Rumours flew that the Mounties had missed the bulk of Everett's fortune. Visitors to Halifax reported that a gallery was selling the Maud Lewis door for a tidy sum of money. What would the stairs be worth?

Jennings acted quickly to protect the building with a plywood shell. It was waterproof, stout, sturdy and lockable, and gave notice to thieves and vandals that someone was looking after the place. It seems unlikely the Maud Lewis House would have survived that first winter if Jennings had not built this plywood cover. Yet in 1979 and 1980, Richard, vexed by negotiations for its purchase, publicized his opinion that the cover had accelerated decay within the house. In fact, the cover, while sturdy and waterproof, was hardly airtight. The house was damp because it was no longer heated and rested on the ground. Like any other unheated cottage in Nova Scotia, the Lewis House was destined to rot, covered or not, from the ground up, not the top down. Be that as it may, the bickering continued to postpone the restoration of the Lewis House.

In 1980 Jennings sold the Lewis House to the society for $11,000—not a great sum, but more than the Society could afford. A financial crisis ensued from which the Society never recovered. In a generous attempt to assist, Jennings did not require the purchase price to be paid at once. Further, the Province of Nova Scotia gave the Society $5,000. These were happy events, but highlighted a weakness in the Society's efforts to raise their own funds. The membership fee in the Society had been pegged at such a low level—$2—it was below the cost of administration and made the Society's efforts a money-losing proposition. Every time someone joined, the Society lost money.

In April of 1979, under the auspices of the Art Gallery of Nova Scotia, Bob Arnold of the Canadian Conservation Institute visited the little house in Marshalltown. His report stated that the building was rapidly deteriorating. Maud's decorations were still evident on many surfaces within the house, ranging from the flowers on the cooking range to the wooden steps leading up to the loft.

Although the Society was still without the required financing, in 1982 they announced the opening of the house to the public. They reported a membership of nearly 500 individuals, many of whom, however, lived too far away to be of any day-to-day help. They were Canadians and Americans, who had bought a picture or two when Maud and Everett were alive and now were happy to help preserve their memory. The Society hoped that from this membership base and

from the general public it could build their resources with on-site donations from visitors. Barry Jennings was still owed $6,000 on the purchase of the House.

Failure to gain the support of many who could have been of assistance was the Society's self-defeating problem. In addition, Richard was critical of an exhibition of Maud's paintings at Mount Saint Vincent University's Art Gallery and suggested that it detracted from the Society's efforts. He proposed that private collectors of Maud's works should be prepared to donate them to the Society, as they had paid little for them. The collectors declined, in part because of the controversy and bickering, and in part because the Society had no place to safely keep them.

To compound matters, higher estimates for restoration surfaced. In 1982 the group announced that $40,000 was urgently needed to halt deterioration of the Maud Lewis House. This figure was met with some scepticism. There were skilled local carpenters who could have replaced rotting timbers and sills and placed it on a foundation for less than a four-figure amount, lumber and labour included. There was nothing historically significant about a rotting sill.

Recognizing the problems within the house, in 1981 the Society permitted some memorabilia to be removed to the Art Gallery of Nova Scotia. Every month of wind and rain wreaked further damage. As time passed the funds required continued to escalate, to $46,000, to $50,000. It was said that $20,000 were needed for the foundations and underpinnings alone, seemingly an exorbitant sum for such a small structure. The Society simply did not have the money and it was running out of time.

By late 1982 the Society was in serious trouble. Even Richard's generous loan of $6,000 was becoming a problem; the Society couldn't pay it back, and Richard was far from wealthy. His accounting practice and the Society's duties were a burden for an elderly man. He was disappointed, to say the least, and unfortunately he died with his desire to see the preservation of the Maud Lewis House still unfulfilled.

By 1984 leadership in the Society had been taken up by Jock Bagwell and Stephen Outhouse, but the opportunity had passed and there was little they could do. In a generous attempt to revive interest in Maud's house, Stephen carved a large and detailed three-dimensional wooden portrait of Maud and Everett before their little house. He donated the proceeds of the sale of this carving at an auction at the Lord Nelson Hotel. By this time the interior of the Lewis house had become a shambles, dark and mildewed. Maud's paintings were flaking off the windows and stairs. The old cast iron range, without a fire, was rusting badly.

Facing page: The salt tide is rushing up to meet a freshwater brook, a happy image unique to Maud Lewis and her Nova Scotia home.

Waiting for the Sara Shirley, undated
Oil on board
22.8 x 30.5 cm
Collection of the Woolaver family

Finally, in June 1984, the Society approached the Art Gallery of Nova Scotia to take over responsibility for the house. At the Gallery's request, the Province of Nova Scotia purchased the little house, lifted it off the site and stored it in a building owned by the Department of Lands and Forests. At the time, the Art Gallery of Nova Scotia was expecting to place it in new premises, yet to be constructed, on the Halifax waterfront. With the purchase of the house the Richard loan was repaid.

The failure to establish the Maud Lewis House on its original site was not a failure of the Society. Its placement with the Art Gallery of Nova Scotia was probably a proper solution all along. The divergent, industrious but amateur attempts of the Society could only have coalesced and succeeded in partnership with a professional organization. Those who have visited the Art Gallery of Nova Scotia, now located in its new quarters on Hollis Street at Cheapside in Halifax, would concur that the legacy of Maud Lewis ought to reside within a public gallery. Maud's work was never of purely local concern and her paintings were dispersed throughout North America. A safe and lasting home was always Maud's desire, and we would wish no less for her legacy.

Reflections
Epilogue

In 1995 I made a journey to Marshalltown, Digby County. I was not expecting to find anything in particular but I wanted to recapture my earlier and stronger feelings about Maud Lewis. Somewhere in the whirlwind of activity that had become a play, a biography and an exhibit, something had been lost.

It was my understanding that Maud did not value her paintings very highly. She did not think of herself as an artist, but as one of the many craftspeople working in Digby County—barrelmakers, decoy carvers, boxmakers, rug hookers, canoe makers and basketweavers. There were painters too, like Maud, and photographers travelling the backlanes with tripods and glass plate cameras. There were quilters whose decorative and original designs were destined to out-live their creators, gracing beds in all parts of the United States and Canada. The quilts, sold at Bert Potter's in Plympton, on the way up the coast from Yarmouth to Digby, were Maud's competition for the roadside tourist trade.

As valuable as Maud Lewis paintings had become, they were not the most costly of artworks produced in rural Nova Scotia. This honour went to the decoy carvers, whose early carved waterfowl now fetch prices to rival Audubon prints, in the tens of thousands of dollars, in the American auction houses. No Maud Lewis painting has ever sold for that amount of money. The record is still the $5,000 paid by the Province of Nova Scotia for the Maud Lewis door. The decoys were largely the work of unnamed artists. Some were weighted to float in a natural manner, and others whittled to stand on spikes to be driven into the marshes; some had hooks fore and aft to be tied in a line, or raft, to appear on a rising tide like a flock. Sadly, most of the best went south with the predations of the antique pickers.

Among Maud's other contemporaries were the Digby barber Harry Trask, and the sign painter Boob MacNutt. I thought that if I went to Harry's old barbershop in Jew Cove there could well be a Maud Lewis or two hanging on the wall. Harry himself attempted fine art in an untutored way, and while his paintings failed to draw much attention beyond Digby, they were admired locally and won prizes at the county fairs and competitions. Next door to Harry's shop were the offices of the *Digby Courier*, where Edith Wallis had once written about Maud and displayed two of her paintings. My little venture was unsuccessful. Both Harry and Edith had passed away. Harry's shop was closed, the *Digby Courier* had been purchased,

Facing page: Maud painted this brother and sister happily skating on the frozen pond shortly before her death. In the background, a sleigh brings a single driver home, and, in the distance, the church windows are illuminated.

Untitled, undated
Oil on particleboard
30 x 36 cm
Private collection

and not only was there no evidence that Edith Wallis had once operated Wallis print and the *Courier*, the precious files and old photographs had been removed, and with them, the early black and white photos of Maud and Everett Lewis.

I left Digby, following as closely as I could the route of Maud's eventful trek to Marshalltown. The old railway trestle which Maud had scrambled up and over was gone; even the train tracks had been taken up. I passed an abandoned road where a dulse picker had spread a load of his harvest to dry. The sign "Dugas—Quilts for Sale" greeted me, followed by another pointing up the Ridge that read "Rapure Pie—Fresh and Frozen." I glanced at Stephen Outhouse's folk carvings standing on the green grass like a community of released Poor Farm inhabitants, blinking in the sun. His words of gratitude, spoken only a few weeks previous came to mind: "You know Maud, she was the mother of us all. I never would have believed that the time might come when I could give up carpentry and support myself by doing the thing I love most, carving."

Although the Lewis house had been removed, I thought that one or more of Everett's sheds might remain. I was wrong. There were wonderful ripe raspberries, sweet and warm in the summer sun, growing where Maud used to sit on the patch of lawn. I began to poke about in the grass and raspberry bushes. I knew that there was no point digging about for Everett's buried jars of coin and cash. That had been done many times before by those armed with metal detectors and shovels.

My memory, however, served me well. I was able to locate the spot where their house had once stood, and the concrete building block, half-buried in the earth, that once propped up Maud's trailer. I made two discoveries. The first was Everett's rubbish heap, where I found an old metal bowl, carrying the little dabs of paint and flowers characteristic of Maud's work. It hadn't rusted because it was enamelled, and the oil paint had resisted the wind and rain of nearly thirty years. I put the bowl in my car and went back to my search.

Not far away in Bear River, my father had sixty of the best Maud Lewis paintings, but there was still something that drove me to dig about in a garbage dump, something I still wanted to know.

The final discovery did not look like much; it was badly rusted and the glass had broken into four large pieces. It was the clock that Maud had brought from her mother's house in Yarmouth, the clock that Everett had been unable to sell for a dollar or two and had thrown away. Its tin face shone out the tell-tale adornment of Maud's handiwork.

Just as the sun had risen every morning, lighting up the window where Maud would paint, so too the clock had marked the passage of more than three decades spent in the little house beside the road in Marshalltown. It accompanied Maud through her daily existence of poverty and pain as she drew from her heart a world of joy and colour and laid it out on every surface she could find, to smile back to the world.

Winter Scene, Circa 1950
Oil on board
29.5 x 34.8 cm
Collection of the Art Gallery of Nova Scotia

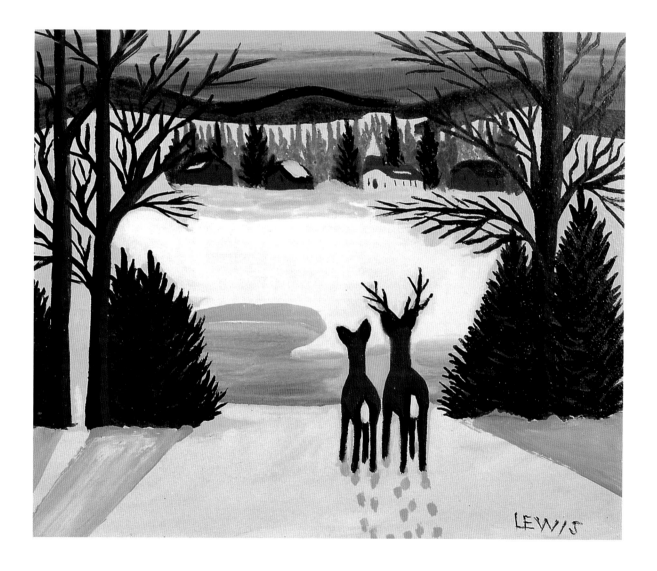

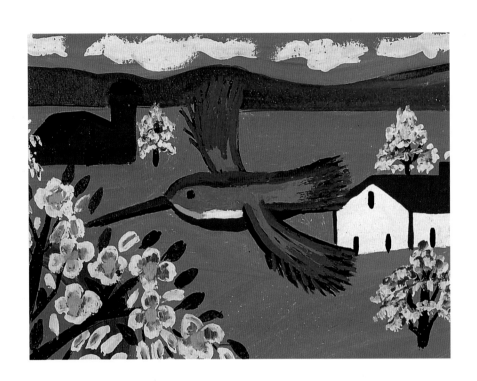